THE ARTIST'S GUIDE TO HIS MARKET

THE ARTIST'S GUIDE TO HIS MARKET

by Betty Chamberlain

WATSON-GUPTILL PUBLICATIONS/New York

Copyright © 1970, 1975 by Watson-Guptill Publications
Revised, enlarged edition first published 1975 in New York by
Watson-Guptill Publications,
a division of Billboard Publications, Inc.,
1515 Broadway, New York, N.Y. 10036

Library of Congress Cataloging in Publication Data
Chamberlain, Betty.
 The artist's guide to his market.
 1. Art—Marketing. I. Title
N8600.C48 1975 658.8'09'7 75-6896
ISBN 0-8230-0326-4

First Edition, 1970
 First Printing, 1970
 Second Printing, 1972
Second Edition, 1975
 First Printing, 1975
 Second Printing, 1976

In memory of
Just Lunning and Ben Shahn

CONTENTS

THE
ARTIST'S
GUIDE
TO HIS
MARKET

INTRODUCTION

If you are a fine artist, how can you find a place to exhibit your work? This is a universal question. As one painter has summed it up: "The greatest problem which professional painters and sculptors have is that of finding exhibition space. Where to show his work? This is becoming increasingly difficult. The galleries have a full roster of artists; there are few co-operatives, juried shows which are limited in size, too few art associations—in short, fine artists face the discouraging situation of being unable to find places to exhibit."

The mental and psychological strain of the situation is manifest in a recent comment by a New York artist: "I have spent years cultivating the esthetic sensibilities only to have run dry of the stuff that makes artists known. I cannot paint pictures and have the pictures stack up in my apartment. All the worthwhile effort is wasted. Negative feelings arise, and many questions are raised as to why I paint with such fervor. . . ."

And a leading New York dealer just wrote me saying: "From my observation I would say there are as many good artists not in galleries as there are those who have galleries."

These problems are certainly very real indeed and have been growing steadily; for despite the increase in the numbers of galleries, the number of serious artists has grown much more. This book aims to provide information of a practical nature to artists who are seeking to overcome these difficulties of exposure and sale of their work. It supplies information about dealers and their practices, derived from art galleries large and small, in New York and elsewhere, as

background material to help guide the artist. The dealer in business, and those who plan to go into the business, may well find this information useful as a yardstick for accepted practices.

Art Information Center, Inc.

Most of the information given here is derived from years of experience with thousands of artists and hundreds of dealers. Not much has been published on this subject. In 1959, the author established the Art Information Center, Inc., in New York City, a non-profit, tax-deductible organization (the only one of its kind so far in the U.S.). The Board of Directors is composed of the following, in alphabetical order: Betty Chamberlain, Stanley William Hayter, Jacob Lawrence, Andrew Carnduff Ritchie. Founding Board members included the now deceased Just Lunning, Joseph B. Martinson and Ben Shahn. Assistant Managing Director is May Asher. The information in the book is largely based on the work of the Center and the many researches required of the author for a number of years of writing *American Artist* monthly articles. The purpose of the Center is to give free asistance to artists who wish to find outlets for their work, and to dealers who seek new talent. It also helps curators, collectors, the art press, and the general public to locate the work of any living artist.

The Center came into being as a result of eighteen years of experience in museum work, during which it became apparent to me that museums were unable to supply much help in these directions, although there were ever-increasing needs. The number of artists and galleries both mushroomed after World War II to the point where neither artist nor dealer could keep up with the growth, nor could they have any over-all perspective on the art scene. Thus the artist was at a loss to know where to try to show his work, and the dealer did not know how to help him. Confusion, disappointment, and discouragement resulted. Moreover, no one knew how to find out where to see or buy work by the thousands of living artists who *did* have gallery affiliations, for there was no source of information on what gallery handled which artists.

Services to Artists

The Art Information Center, Inc., was therefore set up as a clearing house of information in these areas of contemporary fine arts. It asks

no fee or commission of anyone at any time. It sees by appointment some 800 artists per year and, on the basis of slides or photographs of work brought by the artist, it suggests some New York galleries most likely to be interested in the particular kind of work. These recommendations are also made partly on the basis of knowledge as to which galleries are more apt to be able to take new work. For many dealers have a full roster and see no point in wasting everyone's time by looking at any more work. Indeed, most New York galleries refer artists to the Center when the artists just walk in at random. The dealers are glad to be able to give the artists some directions; many an artist has learned in this way about the Center's services.

Needless to say, in order to know what kind of work the galleries are handling and what their situation is, it is necessary for us to go to visit many every week. For verbal descriptions without the visual actuality tend to be meaningless—works of art are not easily categorized. Nor are "directions" of galleries. If they were, if the whole feeling of the contemporary art field could be computerized, then IBM could do the job. But I have seen too many hundreds of artists who have had to gird their loins even to come to the Center, and who dread facing a dealer. To subject them to computerizing, to hand them a "canned" list, would be a most discouraging brush-off just when they need that least.

All artists who come by appointment are invited to call the Center if, in going to galleries, any questions arise in their minds about terms proposed or if there is anything else on which they would like to consult. The Center encourages artists to report any questionable procedures which they may encounter among galleries they approach, for in this way, we are better able to help the next artists who come to the Center. It is impossible to tell by the looks or the location of a gallery whether or not its operation is conducted on a professional basis. Sometimes artists deviate from the list given them and wander in to see a dealer who welcomes them warmly, enthuses over their impressive talents, offers a one-man show. Usually these are non-professional galleries, and if the artists phone the Center, they are always so advised frankly. For affiliation with such galleries would not only cost the professional artist undue sums of money, but could also hurt his professional reputation. There is nothing illegal about such galleries, and perhaps they serve a purpose for amateurs. But when the Center learns of instances of complete misrepresentation on the part of any gallery, this is reported to the Better Business

Bureau, the Art Dealers' Association, and the State Attorney General's Office.

The time it takes to see each artist, to study his slides concentratedly, to select about ten or twelve suitable galleries for him from a list of some 400 New York galleries—plus inevitable incoming phone interruptions—runs from about forty minutes to an hour. This is often hard for artists, seeking immediate appointments, to understand; they wonder why they can't just drop in for five minutes. In addition to compiling a selective list of galleries for each artist, the Center gives each artist some information on practices and procedures, appropriate approaches to dealers, business terms to seek, what to look for, and what to look *out* for in outlets for display.

But obviously this personal service must be limited, since there are so many artists who are too far away to visit the Center. Moreover, we can only refer artists specifically to New York galleries; it is all we can do to keep up with the hundreds right here, without attempting to know individual galleries elsewhere. Yet, often it is far more advantageous for artists to show closer to home. With concepts of what are correct and useful procedures, artists can be better prepared to solve these problems, wherever they are.

The following chapters aim to disseminate such information not only much more widely, but in more complete detail than is possible in appointment periods. Even if you can visit the Center for individual help, you should derive from these pages much supplementary information which is equally important. And if you cannot make a personal appointment, there are many suggestions here on how to determine your own best procedures.

Two recently added services for artists are available free from the Center.

The Educational File. An up-to-date record of where special art or craft skills and disciplines may be developed in courses and workshops; winter and summer, daytime and evening; children up to 16 and adults; on subjects ranging from Chinese brushwork to stained glass, tapestries, medical illustration, ceramics and pottery, jewelry, and art therapy, as well as painting, sculpture, and graphics.

Summer Outlets. Files on open and competitive exhibitions held in many parts of the country during the summer, which is often a difficult time for artists to locate outlets.

Information on either of the above is available by telephone or by

mail, if return postage is enclosed. These new services have been developed with the aid of a grant from the National Endowment for the Arts and matching funds from foundations and individual contributors. Additional information from all art organizations is always most welcome.

Services to Dealers

Each artist who communicates with the Center is invited to leave or send in duplicate slides or photographs, so that dealers who come in, seeking new talent, may select from these reproductions any artist whose work is of interest to them.

All reproductions left at or sent to the Center should be labeled with the dimensions of the originals, the medium, and the artist's name. Size is often important to galleries, and it is impossible to determine it from a tiny reproduction; medium can also be confusing in reproduction; name is essential on each slide because dealers inevitably mix up the slides they have viewed, and then no one can know where they really belong.

An interested dealer then gets in touch directly with the artist, usually arranging to visit his studio to see originals. Occasionally, when geographical distance is a problem, the dealer may ask the artist to send a few works. There are usually some 700 to 800 unaffiliated artists represented in this record of reproductions at the Center—a file which, of course, changes constantly as some artists find gallery affiliations and are removed, and new artists are added.

Many dealers, both in and outside of New York, have obtained their artists in this way when they were about to open galleries. Frequently, dealers come from far-flung areas, seeking to represent and show in their regions some interesting new artists from "the effete East," or from "the art center of the world." Naturally, dealers prefer to select an artist who does not have a contract with another gallery, for this would require them to split commissions with the other dealers. In some cases, the Center receives a written description of the kind of work desired by a dealer who is far from New York; the Center then selects some reproductions to send on a short loan.

Services to Museums, Collectors, Art Press, General Public

The Center keeps up-to-date records of living artists who have gallery affiliations, and anyone may call or write to locate their work. At

last count there were more than 45,000 living artists listed, with their gallery affiliations, since the Center was founded in 1959. In order to maintain this record accurately, a form is sent each September to all New York galleries and to a great many others in cities throughout the U.S. and abroad, on which the galleries list the artists they represent and handle. Because artists frequently change their gallery affiliations, the records must be checked and changed at the beginning of each season (the art season in New York is roughly from late September to June 1), because there are so many changes from one seasonal contract year to the next. In addition, the Center is on a great many mailing lists, and all information is regularly listed from brochures and announcements. All listings from major art publications, art columns, and advertisements are also checked regularly.

It should be stressed that this information aims to apply only to the fine arts. The Center does not work in the field of illustration or commercial art. And naive purchasers who buy in some out-of-the-way shop, after a sales talk about how "famous" the artist is, may be doomed to disappointment when they call the Center, only to find that the artist is not listed because he has never shown in any recognized gallery. Of course, no listing is complete. But if an artist is not listed in the Center's files, two other compilations are always consulted: *Who's Who in American Art* and the Berlin-published *International Directory of Arts*.

Hundreds of calls and letters, seeking this service, come into the Center; no record of how many is kept, for the Center is too busy answering them. Museums are anxiously looking for a particular artist's work to fill out a planned show. The Internal Revenue Service wants to know all galleries who have ever represented certain artists in order to obtain three appraisals each on works of art to be given to public institutions as tax-deductible gifts (some donors try to get away with a tax deduction of several times the value of the donation). An art writer or reviewer needs to check on work by a particular artist. A businessman wants to buy paintings by certain artists for his offices. A housewife has seen a sculpture in a friend's garden and wants to buy a similar one by the same artist. A tourist is particularly anxious, while in New York, to see work by so-and-so. There are even, from time to time, inquiries for the purpose of settling a bet or solving a crossword puzzle.

Collectors sometimes call anxiously for an artist's home address, but this is never revealed by the Center unless the artist has no gal-

lery affiliation. For too often their purpose is to bypass the gallery commission and try to talk the artist into selling at lower prices.

Other Services

The Center never attempts to duplicate any information service which is available elsewhere. If people inquire for artists' biographies, they are referred to their galleries. If they are looking for grants and fellowships, they are referred to the listings in the back of the *American Art Directory*, in the *Fine Arts Market Place*, and in the American Association of Museums' monthly supplement to *Museum News*. If they want to enter competitive shows, they are told which publications list them, such as *Who's Who in American Art* (at the back), *Fine Arts Market Place*, and the monthly *American Artist*'s "Bulletin Board." If they need to refer to critical reviews, they are referred to the *Art Index* in the public library. If they want to know what museums and art schools exist in any part of the country, they are referred to the *American Art Directory*. The Center tries only to fill gaps where the information does not exist anywhere else, and to direct and guide people to other sources of information which do exist.

All inquiries requiring an answer should enclose return postage, in view of the fact that all services are free and funds are minimal. Conforming to the New York art season, the Center is open only from mid-September to mid-June.

1

ARE YOU READY TO EXHIBIT?

How can you know whether you are professional in your work, still a student, or really an amateur? In extreme cases, doting mamas sometimes try to push their teen-age darlings into gallery shows because their high school art teachers graded them well after their first year or two and mentioned the word "talent." Obviously, the serious-minded artist knows that the urge and the realization must come from within, not from goading or flattery by relatives and friends. It is an old dictum that no one should try to become a fine artist unless he has to, when the inner drive is too strong to overcome. For the pursuit of art as a career is generally not only unremunerative, but costly; the competition is fierce; and real recognition is achieved by only a small percentage.

A naive but direct inquiry about this dilemma came to me from North Dakota: "Will you please send me information on how to become an 'established painter'? What is the process by which one is established? Also how to judge between using another picture for reference, and plagiarism?"

Professional or Amateur?

"Professional" versus "amateur" is a chronic dilemma, a constant source of arguments and differing points of view, and a major concern in many inquiries I receive.

"At what point and by what standards does an amateur artist become, or consider himself, a professional artist?" writes an artist

from a small city. "Judging by many of the art shows around here, 'professional' is anyone who can produce and sell a painting."

There is no rule of thumb or set criterion for making such determination, so far as I know. Several years ago, I was requested to select artists to be newly included in *Who's Who in American Art*. In trying to pick those to be considered "professional," I was influenced by inclusion of their work in recognized museums more than by inclusion in private collections. True, many museum-owned works were donated by the artists, whereas collectors generally paid. But it is usually harder to get a museum's acquisition board to accept a work, free, than to get a friend or relative to buy.

Artists frequently categorize themselves quite obviously on the basis of their degree of ego. Some who have shown once or twice proclaim themselves professionals; others with much broader experience are full of doubt as to their status.

Surely sales alone are not a conclusive factor, for we all know about sales of very amateurish work, and about non-sales of much more skillful and competent work. No wonder there is confusion as to where and how to draw that fine, undefinable line between amateur and professional.

Plagiarism

Using another picture for reference is, in itself, of no great import, for the source of a subject does not matter. It is the handling, the treatment, the originality of style injected that stamps the work with the artist's personal expression.

Titian copied a Dürer landscape drawing and labeled it as such. It is a prized possession of the Albertiner museum in Vienna. Van Gogh copied Millet; Picasso did his version of Manet's *Déjeuner sur l'herbe*, which in turn was derived from Giorgione's *Fête champêtre*. Each is fully imbued with the copying artist's own unmistakable style; thus, these masters were not plagiarists.

To plagiarize is "to steal and use as one's own," according to Webster's. This is obviously misrepresentation, and this is part of why copyrights exist. Imitation of another artist's style, while not illegal, is widely censured. As soon as Andrew Wyeth became one of the highest-priced living artists, there was a rash of imitation Wyeths by opportunists without originality. It is indeed doubtful that any of them will hold up either in time or market.

Some Questions to Ask Yourself

There are other, perhaps more intrinsic, criteria to consider. It may help you to ask yourself some questions.

(1) Do you work on a steady, regular basis, or are you "spotty" and interrupted in your output? Some artists work very slowly. Peter Blume, for example, may have spent twelve years on one painting and all its preliminary drawings and sketches. But such artists nevertheless work regularly and consistently, not on an "I must wait for the mood" basis.

(2) Do you differentiate between your better and your less successful work? Do you "sleep on it" to get perspective so you can judge what to keep and what to discard? This is important not only for future exhibition purposes, but also for your own development and for where you place emphasis and direction. I was gratified indeed when I received an unusual note from a New York artist: "Kindly cancel my appointment; I will contact you later. I have come to the realization that the work I have been doing is not up to what I want to do." For it is only this kind of self-realization that is of value; no one else can do that for you.

(3) Is your style consistent? True, many artists work in more than one style at the same time. But usually, in the case of an artist who has "jelled," there is a strong vein of similarity, unity, and consistency, even between two fairly different styles. Or the artist, on self-examination, realizes that he is really leaning more towards one of his directions, sometimes using others for experimentation, practice, breadth of development—as studies for an ultimate production. If you go in too many different directions at once, you may well spread too thin in all of them.

A Singaporean Chinese girl wrote, wanting to come to the United States: "I am artistically inclined, but I feel frustrated here . . . my artistic talents are just not exploited. What I would like to do: architecture, pottery, ceramics, fashion designing, stage designing, sculpture, portrait and figure drawing in all media, and abstract art." You have to admire the ambition of such a project!

If you are still trying out numerous approaches and are not sure what really speaks for you, then perhaps you are not ready to show.

(4) Do you have a sufficient body of consistent work to show? Dealers generally want to see some fifteen or twenty, recently executed by

the artist, before deciding whether or not to show him. They are not interested in work done earlier in a different style until you become old and famous, like Picasso, who warranted retrospective exhibitions during his lifetime, showing development in various periods. They want work in your current style, which is likely to continue to come out of your studio for at least some months ahead. What to do with a body of work in a previous style? Forget it. Perhaps put away some of the best for your future perusal of your development; perhaps give some as a present to your mother-in-law.

(5) Do you try to be "in the swing" of new movements? If you are concerned with bandwagons and bend your talents towards adjusting to the latest fashion, the chances are that your work will not hold up over any length of time. There is always room somewhere for truly creative, original, and talented work in any style, even if it may seem "old fashioned." The faddist, on the other hand, though he may make a momentary coup, is all too likely to wind up as an opportunistic flash in the pan, usually smacking of obvious imitation and repetition.

An artist, faced with this problem of change in what is "avant-garde" in Europe, wrote from Munich: "Excuse me, that you receive herewith a letter from an unknown person. But I heard you can help painters to get an exhibition in N.Y. More I don't know. I made already exhibit in Paris, but in Paris it is very difficult since 2 years with the abstract paintings. I like to exhibit my abstract aquarelles next year. Should I show perhaps with figuratives and flowers?"

If the work is not really yours, emanating from your own basic need to express it your own way, better not do it. Or if you do it just to prove to yourself that you can, don't show it.

(6) Do you expect to make a living from your art alone? Even those artists who do have reputable galleries representing them run into many difficulties.

John Canaday, formerly art editor of *The New York Times*, who wrote periodically on the plight and problems of the artist, described one, "typical of many, whose increasing reputation, after exhibitions of his work in a series of major shows, is nevertheless not reflected in increasing income."

He also reported on the experiences of another artist who, he says, faces "a problem faced by all artists, that of exhibition in a New York gallery." This artist, who had had eight New York shows in the

previous sixteen years, "must seem to most artists to have achieved more than average success," said Mr. Canaday. "His gallery is an old, well-established one, not particularly aggressive but much respected—dependable and financially stable." But "expense is certain and profit is at least uncertain from a gallery show," and Mr. Canaday went on to quote the experiences of this seemingly fortunate artist: after paying the required costs of framing and publicity for his latest one-man show and selling ten paintings from the show, he cleared a total of $470 "to cover the cost of paints, canvas, and studio space for the two years' work represented by the exhibition. . . . The gallery's side of the story is that it took in about $325 a week to cover expenses during the three weeks of the show. This is obviously much less than it costs to run the place."

The artist told Mr. Canaday: "There is no asset for the average artist like the socially gifted wife. From all of this, it is pretty apparent that I have exactly three choices. I can find myself such a wife, or I can kill myself, or I can continue to support myself by teaching, which I am quite happily committed to doing."*

Only a handful of top-name artists are able to live by their creations; indeed many who are well known still must do something else for livelihood. There is an informative discussion of this problem—and of some of the other ways in which artists make a living—in the book, *Art Career Guide* by Donald Holden (Watson-Guptill Publications, New York 1973, pp. 67–69). It is unrealistic, wishful thinking on the part of any fine artist to believe that he is going to earn his living by his works of art. Should it happen in the course of time, it will be a great bonanza—but don't count on it.

Earning a Living

Better to try to figure out a job for yourself which permits you as much time as possible for your art. Some artists prefer related work, like teaching or commercial art; others prefer a complete divorce between their money-making and their chosen profession. Some are able to work remuneratively at engineering drafting or an applied art, producing an income in only three to six months sufficient to leave them completely free for their own work the rest of the year. Many work full-time, regular job hours, and still have the drive for a

large art output in their spare time. One of the most idyllic artist-jobs I have heard of was that of a Northwest artist who sat painting for many seasons in a forest fire tower north of Seattle, paid to keep an eye out for smoke.

Museum Jobs

If you seek employment in a museum, there is usually not much value in going to an employment agency; go, rather, to the personnel departments of the museums themselves. Even dealer galleries very rarely turn to any employment agency when they need assistants; they are more apt to use the grapevine method. For professional jobs in museums, the American Association of Museums in Washington publishes openings throughout the U.S. in its *Professional Placement Bulletin*, issued as a supplement to its monthly *Museum News*. These are available in most art libraries, or by a $25 membership in the association, open to anyone.

Teaching Jobs

For teaching jobs, there are placement bureaus in the colleges and universities, and the College Art Association of America maintains a placement bureau for its members ($14–$35 per year, depending on income). Such teaching positions usually require a degree in education or some other graduate degree.

All major college or university art departments are listed by state and city in the second section of the *American Art Directory*, along with courses taught, size of enrollment, and other pertinent information, should you wish to apply. There are increasing numbers of artists-in-residence in many of these, as well as in schools below college level; these do not necessarily require that the artist must have a degree, nor that he be well known. Currently, increased attention is given by colleges to the practicalities of life after graduation. For example, the Union of Independent Colleges of Art (headquarters: 4340 Oak Street, Kansas City, Missouri 64111), embracing 10 colleges around the U.S., has started a Career Opportunities Service for placement of its alumni—not necessarily in teaching only.

Those independent art schools which do not give degrees will much more readily employ artist-teachers who do not have degrees. Some of these schools will employ artists only on a part-time basis, for they feel that it is important to his effectiveness as teacher for the

artist to have sufficient time to continue his own work in his studio. Many have evening courses.

Some artists have found employment in various fields through the U.S. Employment Service or through state employment agencies.

2

GALLERIES
AND HOW
THEY FUNCTION

Fine arts galleries deal primarily in paintings, sculpture, mixed mediums, graphics, and in some cases, crafts and photography when considered to be art expressions.

"Art Dealers" Versus "Picture Dealers"

The Art Dealers' Association of America, to which about 100 older, established galleries belong, makes the distinction between a true "art dealer" and a dealer in "pictures." The dealer in "pictures," says the Association, is engaged in "an entirely honorable business, but essentially different from the fine art business." Thus the artist who wrote me from Holland was, from his description, seeking a "picture" dealer: "I am a painter of old Dutch paintings, and should like to come in contact with a person who is buying art paintings, so my question is, if you can give me those addresses." The Art Information Center, however, functions primarily in the fine arts field of "art dealers."

The Art Dealers' Association defines the true "art dealer" as one who "is making a substantial contribution to the cultural life of his community by the nature of the works offered for sale, worthwhile exhibitions, and informative catalogs or other publications. Art dealers in the leading art centers—both members and non-members of the association—perform a most important function. It is the dealers rather than the museums which first discover and exhibit the works of new artists. [Note: Exceptions to this statement surely

should be made in cases such as Alfred H. Barr, Jr., first Director of New York's Museum of Modern Art.] The dealers' exhibitions, which are open to the public without charge, are among the most important 'free shows' of any kind thus available. They represent an outstanding benefit to artists, museums, collectors, and the public generally."

A legal case, based on this assumption of benefit, was won a number of years ago by the Leo Castelli Gallery in New York. Neighbors protested that his gallery violated a zoning law: his gallery was a few feet beyond the prescribed commercial area. However, he proved to the court that he was acting much more as an educational center than as a commercial one: his door was always open, free to all; his carpets were worn out by students and scholars who never bought; his publications were sent free to libraries and universities. The final result was that he was allowed to remain in the same location.

But, on the other hand, the association warns that "art dealers are engaged in business. They hope to operate at a profit. . . . Their galleries are not museums. Their owners and operators are primarily engaged in buying and selling works of art." They go on to warn: "Dealers' galleries are not public service stations and they do not offer to the public drinking water, telephones, or toilets."

Indeed it is well to keep this in mind. I went with a visiting out-of-town artist to a gallery preview, and as soon as she reached the crowded party, she made a bee-line for the gallery's telephone. Fortunately, I was able to distract her and explain that this would not be appreciated. "But it's only a local call," she said, accustomed to unlimited calls in her home town. But aside from the cost of every local call in New York—and why should a dealer pay for all visitors' calls?—the gallery does not want its line tied up by outsiders so no one can reach it.

The Art Dealers' Association of America is a non-profit organization of dealers in New York and elsewhere in the United States, who are elected to membership on the basis of belief in the dealer's knowledge of his particular field and in his complete integrity. The association is active in combating fraudulent practices. A prospective member must have been in business for at least five years, must have a good reputation for honesty in his dealings, and must be considered by the association a true "art dealer." The requirement for ethical standards applies not only to dealings with the public, but also with artists. Any dealer who is a member of the association will doubtless have its booklet describing its activities and listing all its

members, who are generally considered the "cream of the crop" among art galleries. So unless you have already gained a considerable reputation, it is not very likely that you can start out in one of these galleries. But the standards they set are practiced by many galleries which are not members. These standards, which are described in greater detail below, are most helpful to the artist.

Some Standards to Look For

The "professional" gallery charges a commission on sales, but does not require any fees from the artist. This kind of dealer makes his living from sales, not from the artist's pocket. The costs charged to the artist by a "professional" dealer are the actual out-of-pocket costs for publicity for a one-man show, and he is willing to show you the bills for these costs.

If he publicizes a group show, that is *his* financial responsibility, not yours. If there are shipping costs, he may expect you to pay these at least one way. If you are a painter, he will expect you to deliver your work already framed. If you want total coverage in insurance, you may have to supplement his insurance, for almost no dealer carries insurance for 100% of value. These are the terms to look for, based on the concept that the dealer should be in business because he has judgment both for quality and for what will sell.

What to Look Out For

The "non-professional" dealer, of which there are many, may insist on a guarantee against commissions—which means that you assure him of anything from $200 to $5,000 in sales commissions, whether he sells that much or not! Naturally, this removes his incentive for making sales, for he knows that you will have to pay him anyway. And remember that for every $1,000 guarantee you give him, he would have to sell $2,500 worth of your work for him to get the usual 40% commission and for you to get back your $1,000.

He may also charge hanging fees. He may charge costs of publicity for a group exhibition split among the artists showing. His "costs" may include his rent, light, and heat. Thus, a dealer of this variety knows ahead of time that he has his income guaranteed by *you*, and he does not need to bother about even trying to be an active or effective dealer.

These are warnings for the professional artist. For there is indeed a reason for the existence of "non-professional" galleries. There are Sunday painters, amateurs, and retired businessmen who want very much to have a show, invite their friends, have a catalog to show the folks back home, and collect a few press comments from certain small publications which will write a "review" if the artist buys an advertisement. For these non-professional artists, probably the most direct and forthright dealers are the outright rental galleries who have a set fee for a certain amount of wall space.

There is one exceptional situation in which an artist can achieve a measure of professionalism through a rented show. This is when his position or promotion depends on having a New York exhibition. I have known artist teachers in colleges remote from New York who were told that they could only be promoted, with salary increase, if they had a one-man show in New York—a type of "publish or perish" edict transferred into the art world.

A teacher is tied down by his work during the same time of year as the New York art season, hence has not the time to make the trip and shop for a professional gallery. His recourse is to rent a show and thus obtain his promotion. It is a foolish requirement on the part of the college officials, who doubtless do not realize that shows in pay galleries prove nothing about professionalism, and that such a show may even make it difficult for a promising artist later to exhibit in a professional gallery. Their requirement thus indicates not only their ignorance of the field, but also their lack of confidence in their own judgment and competence.

Some non-professional dealers have fees that vary according to what they think the artist will put up with. Some of them go to many competitive shows, take notes on the artists who have no gallery affiliation, and write them, offering them shows and complimenting them on their great talent. (Warning! You can nearly always assume that any such approach comes from a gallery which exists on artist payments rather than on sales commissions, for it is not a practice of professional galleries.) Too often, professional artists are elated by this "recognition" and fall for the costly and "non-professional" show, which, in the long run, can be detrimental to the professional. Curators and press generally avoid these galleries, for the practices are known in the art field, and the "professional" gallery may be dubious about taking on an artist who has had his name affiliated with a "non-professional" dealer.

In case you want to show in Europe, don't be surprised if you find a quite different situation, for charging various fees is a much more commonly accepted practice abroad.

It is pretty difficult to predict whether a dealer is going to be successful, or go out of business, or even go bankrupt. There have been cases in which artists were unable to retrieve their works from a bankrupt dealer because he placed everything from his gallery in a warehouse, where he already owed a large debt. Unless the artists paid his back bills, they could not obtain their works. In one recent case, a number of the artists kept an alert eye on their gallery's proceedings, realized the impending hazard of their dealer's situation, and took their works away in the nick of time.

Even outrageously obvious crooks have been able to pull the wool over unsuspecting artists' eyes for several years, before enough artists became sufficiently aware to put them out of business by not falling for the act. There was a dealer—fortunately now gone—who told artists that the way to start showing was in Europe; after this, they could walk into any gallery in New York and get a one-man show. How artists could have been so naive as to believe such a blatant misrepresentation is hard to understand, but quite a lot did. The dealer took three paintings from each artist, sent them abroad, arranged for some sort of minor press review (easily purchased abroad), and charged each artist $2,500. Many an artist borrowed widely from friends and relatives to pay this, believing that then he would be "made." The Art Information Center reported the dealer to the lawyers of the Art Dealers' Association and to the Better Business Bureau, but neither could do anything legally because, in each case, the artist had signed a statement that he agreed to precisely these terms. The Better Business Bureau could only send the dealer a notice that he was misrepresenting, and that, if asked, they would have to label him thus. But too many naive people do not think to check with the Art Information Center, nor with the Better Business Bureau, nor with the Art Dealers' Association.

Agents

Many an artist asks me to recommend a reliable agent who will take care of all exhibiting and marketing problems for a fee or commission. Frankly, I do not know of any in the fine arts field. Agents are often effective in other areas such as commercial art, the performing

arts, literature. But in fine arts, they are widely disapproved. The responsible gallery owner wants to be his artists' representative without working through a middleman; he wants to exercise his own professional judgment, often partly based on knowing the artist and discussing future plans and directions of his work; he seeks a personal rapport not possible when working through an agent—or through a friend or spouse.

Why the same direct relationship is not required in other creative fields, I do not know. But I would guess that it may be because the art gallery is most often a small operation, its owner making personal decisions about building and maintaining the gallery's image, rather than delegating such authority to subordinates as is common in the larger organizations of commercial art directors' staffs, concert management bureaus, and publishing houses.

Another hurdle is the fact that there have been self-styled artists' agents who promised their clients publicity, prominent TV interviews, fame virtually overnight, only to abscond with the artists' funds. Memory of such precedents lingers, even if these frauds were not legion.

For the big majority of artists, the most reasonable and effective approach to finding outlets would seem to be the do-it-yourself personal method.

The Art Gallery Work Force

The preponderance of dealers, even in the major art center of New York, started their galleries either alone or with only one part-time or full-time employee; and many still have the same sized staff even after five or more years. Although many others have increased their staffs over the years, they have usually added only one or two employees. Thus, this occupation is still perhaps more individual—in an old-fashioned "small business" concept—than most business operations today.

The question naturally arises: with so little assistance in the gallery, how much outside help must dealers employ? Actually, surprisingly little.

There are catalogs, brochures, announcements, press releases to be written. Most dealers particularly enjoy doing this kind of work themselves, and usually do.

There are shows to be installed and dismantled every three weeks

during the art season. This they also do themselves, only occasionally hiring a carpenter in case of unusually heavy material or special construction needs.

There is layout and typography to think about for all printed matter. A tiny percentage of dealers hire a graphic design specialist, but by far the largest number work this out for themselves along with their printers.

For traffic-transportation-shipping needs, they don't hire a traffic manager; they call up an art-trucking firm or, for imported art a customs broker.

For advertisements, the dealers work with agents; but this costs the dealer nothing, for agents get their commissions from the publications in which they place ads.

For accounting, dealers hire someone to come in quarterly. Obviously, government forms and checking the bookkeeping are aspects they do not relish, although they keep their own records in between the three-month visits.

Other outside help is likely to include a cleaning person; if the dealer is a woman, she is apt to prefer a cleaning man who can be pressed into service also for moving heavy objects and opening crates, and installing big paintings and sculptures.

It becomes quite understandable, then, that dealers do not welcome shipments of work on speculation, for their facilities are so limited. And one of the biggest problems is lack of space, for suitable space is hard to find and very costly in every art area of every large urban area.

It is also natural that, since they do so much of the gallery work themselves, they do not welcome a constant flow of time-taking artists who walk into every gallery to show work without first taking the trouble to observe whether or not their work is at all suitable to the particular gallery's direction or style.

3

SHOPPING FOR A GALLERY

An artist is wise to take a little time away from his creative work to explore for himself what are his best initial potentials.

Decentralization

It has become less and less necessary to leave home and "migrate" to some big urban art center in order to obtain exposure, recognition, and sales. The widespread clamor throughout the country for decentralization has been getting results. More and more artists are making it in their own areas without ever going to New York, Los Angeles, or Chicago; more collectors are developing and buying locally; more museums and galleries are gearing shows to their own communities, their own artists.

The future of decentralization looks even rosier, according to scientist Isasc Asimov's predictions in *Modern Maturity* magazine. He points out that the recently developed laser beam produces light in even wave lengths so that there is room for many millions of channels to convey pictures and words beamed from communication satellites. That by the end of the century every person on earth may be able to have his own, and to transmit both sight and sound, an aim not possible to achieve from television because of its limited and expensive channels.

For the artist, I doubt if this means that he would show and sell his works in the big cities via laser, but rather that visual information

and education could reach everywhere, creating greater local acceptance, appreciation, and markets. Then there would be little need for the person or the image he creates to be transplanted elsewhere to achieve exposure and recognition ... which would also be a step towards relieving the energy shortage.

But without waiting for the year 2000, artists are in many cases finding outlets, purchases, and commissions without ever going or showing outside their own regions. These developments are being fostered by National Endowment for the Arts (NEA) grants; by State Councils on the Arts in every state and territory; by institutions such as colleges and universities; by artists' organizations, and by individuals. Look into these various potentials in your area instead of making that expensive trip to a big art center.

To be informed about local developments, you need to read art columns and news in nearby newspapers, see shows, talk with other artists, keep abreast of what goes on in your state and region. As a taxpayer and constituent, express to your representatives and senators, federal and state, your concern for sufficient allocation of funds to your State Council on the Arts for community arts services in all counties. They will listen; there is a widespread upsurge in interest in the arts, even among legislators.

Government Participation

The NEA distributes grants in every state in the Union to either the performing or the visual arts or both (with much more to the performing arts), as well as to museums. In programs such as Outreach and Expansion Arts, it has stressed the importance of reaching areas of sparse population. The State Councils for the Arts receive support from the state, the NEA, and matching grant funds from private sources. In many states, funds are allocated to assist community-based cultural and artistic organizations serving their localities and supplying touring arts services in smaller communities. In some cases, decisions on smaller grants may be made locally by county government bodies and regional arts councils.

There are some 20,000 abandoned railroad stations across the country. Federal and local government organizations as well as corporations are seriously involved in reconstituting them as landmarks and community centers for various activities. A logical use is for local art shows, if artists make their desires felt.

College and University Collaboration

Check with nearby college and university art departments and professional art schools for what collaboration they can offer to local artists. They often have good facilities and resources they can share; they seek local interest and pride in their functions, which might well produce some needed local scholarship sponsors; their participation in community affairs is likely to entice better art faculty. Many are helping to form community galleries as well as showing local work in their own exhibition areas. Many are supplying the important forum for artists needed for stimulation and fulfillment.

Artist Group Activities

What are your possibilities of organizing or joining open-studio shows by artist groups or individuals? These are attracting increasing attention and sales in many parts of the country. You don't have to solicit grants or raise funds. They have greater appeal to many than the gallery, for the purchaser is permitted to see behind the scenes of art, to meet the artist in his own surroundings and talk with him about art.

Other artist-inspired and coordinated group activities which are becoming more numerous include open art shows and juried annuals for regional, sometimes nationwide artists, in both summer and winter. In some areas, artists issue small, inexpensive publications as aids to interesting the public in new work, and to supplying the artist with useful, practical information about upcoming exhibitions for potential participation, about problems of publicity, and other mundane considerations. There are also groups of artists who arrange traveling shows of their work to circulate in other communities in their region.

Go to See Shows

In large cities, where many galleries are concentrated and where competition for clientele is sharpest, galleries are likely to specialize in some particular style or type of art expression. The best time to get a perspective on a gallery's direction is when it shows a few examples of work by each of its artists in a group show, so that you can get an overall picture. Such shows are frequently held at the beginning and the end of the season, and prior to Christmas.

In smaller regions and suburbs, where there is less competition, galleries are more likely to show work in various styles in order to appeal to all tastes among potential buyers.

In either case, when you go to shows, make notes for yourself on what you saw where, including styles, mediums, sizes, prices. If you keep systematic records of this nature, you will be in a much better position to sort out—from among all the galleries, large and small—where you might best try your luck. Some galleries show no sculpture, but a few handle sculpture exclusively; some show only smaller work, often because of the size of the gallery; some handle prints and drawings as well as painting and sculpture, while a goodly number works only with graphics.

If you work primarily on paper—watercolors, drawings, prints—look for galleries that especially handle them and be prepared to realize that the more "expensive" galleries may feel they cannot afford to handle your output. For "papers," being less permanent, usually bring lower prices than canvases or sculptures and may take up just as much wall space. Dealers with high overhead costs need to hang higher priced work. They relegate the papers of their artists—who also produce in more expensive mediums—to portfolios in the back room for those customers who say, "I like this artist's work, but haven't you something less costly?"

This fact does not mean that your papers will not find a market; it means, rather, that you are more likely to find your market in galleries located where rents are lower than in the major art section of a city, or else in the suburbs. Galleries often charge a higher commission—up to 50%—on papers.

If you straddle the art-craft fields, you may still have some difficulty in finding outlets, but this situation is definitely improving. A bronze pot may well be a work of sculpture; a stained-glass panel or a tapestry may be as fully a work of fine art as a painting. But the tendency has been to classify such works as craft rather than art, simply because of their form or medium. Now, instead of being limited to art-craft gift shops and showrooms, widespread outlets are opening up in museums and in crafts-as-art or art-objects galleries. Moreover, the NEA has given a shot in the arm to this change in attitude by issuing numerous grants especially to stimulate and foster creative crafts all over the country.

If you are a creative photographer, again your display potentials are improving. There are not only more photography-as-art galleries, but—as is also true of crafts-as-art—there are more galleries

and museums combining their interests in showing these forms of expression along with painting, sculpture, and graphic work.

These things you need to know, in order to approach potential outlets intelligently.

Gather Information and Background

If you know other artists, some of them perhaps more experienced, pick their brains. Not infrequently, an artist who has a gallery affiliation has taken a friend to his dealer when he knew that there was an opening in the roster, and has thus placed him. But even if the result is not so direct, other artists may know more than you do about the reputations, practices, and availability of certain dealers. Add these impressions to your notes on galleries.

If you will study and analyze various galleries in this way prior to asking them to look at your work, you will be in a much stronger position when you do select the galleries to try, for you will have a better awareness of where your work may find its proper surroundings and audience. One of the most discouraging aspects of a dealer's life is the fact that so many artists just barge in, with no regard for or knowledge of the gallery's direction, mediums handled, price range. Indeed, some artists actually bring out slides of, say, landscapes to show a dealer when—if they would only look at the gallery display right around them—they could easily see the dealer specializes in abstract sculpture.

Even in the immediate environs of New York, where it should not be too hard to learn about what is going on next door, an artist from a nearby suburb wrote to me complaining: "Most of the galleries seem to have turned to either Op, Hard-edge, or some other crazy 'way-out' stuff, or 'pornographica.' Is there really no hope for artists like me, whose work is figurative but contemporary, yet not 'far out' or conservative?" It is a plaintive plea, but it is obvious that this artist neither reads much about shows in New York, nor goes to very many, despite his proximity.

I would guess that a similar lack of effort to inform himself afflicted the artist who wrote from Massachusetts: "Few months ago I spent a couple of days in New York 'trying to sell some paintings' to galleries who didn't know me from Adam. Needless to say I wore out a good pair of shoes for nothing. Someone gave me your address just before leaving but somehow you were out. Believe it or not, I didn't have enough money to stay one more day."

If your ultimate aim is the big, urban art market, then first build up your reputation; keep records of sales you have made and copies of press reviews you have received on local shows, of brochures and announcements, of collectors who have purchased your work. Some experience, no matter how modest it may seem to you, always looks better than none at all, and can serve as sales talks for the dealer to use with potential customers.

In some ways the out-of-town artist has it easier, for exhibiting and receiving recognition is not as difficult outside the major art centers. In the same week, I recently talked to two artists, who proved to be extremes in the two situations. One was a New York girl who had just started painting, but thought she had it made because she lived in the art center of the world. Having painted all of two pictures, she was already looking for a dealer! By way of contrast, an artist who came here from California had spent years showing wherever he could in the West, entering juried shows and winning awards. He had built up a very impressive list of some forty such recognitions before ever approaching the New York market. Needless to say, the Californian found gallery representation; the New Yorker did not.

Artists in Foreign Countries

A great many artists in countries around the world write to me saying, "Please arrange a one-man show for me in one of the best galleries in New York." Some add a request for a series of shows throughout the U.S. Frequently, they have obtained the name and address of the Art Information Center from the United States Cultural Attaché or from the United States Information Service officer in their country—individuals who don't know how to satisfy such requests any better than I do. The most difficult and poignantly naive inquiries arriving at the Art Information Center from artists seeking gallery outlets come from those who live in areas geographically so remote from any major art center that I am at a loss to know what to suggest.

From Ghana I received this note: "Exhibition of Drawings and Paintings: I am a 33-year-old Ghanian (African) lecturer in the Faculty of Art. I am also a practicing painter and have held exhibitions both in Ghana and in London. I paint mostly in oils and gouache—mostly on Ghanian life—working, dancing, worshiping, marketing, etc. I have quite a number of my paintings on slides. . . . Do please let me hear from you as soon as you can. Thanks."

What can I suggest to such a person other than that, since he got once to London, maybe he can develop permanent representation in a gallery there and possibly be "found" by a scouting New York dealer—who is most unlikely to scout in Ghana (although this situation may soon change, now that Africa is the "in" place to travel).

An investment company in Australia wrote: "Our present concern is to explore the possibilities of introducing the work of Australian artists to collectors in New York as part of a scheme of exhibitions. The idea is to find a known, good gallery in each of a number of cities who would be prepared to show our Australian collection perhaps once a year and hold a modest stock for sale at other times, act as a centre for enquiries, etc."

It never even occurred to this firm that a "known, good gallery" would have its roster pretty full and would be able to find other worthy artists much closer by; or to consider all the freight and insurance costs; or to realize that a good dealer naturally wants to see orginals before making decisions. And suppose he doesn't like them after they have come all that way? Geographic location, when it is remote, does indeed play a part. I hope you don't live *too* far away!

In many cases, the artists have never even tried to exhibit at home; they actually seem to expect to start at the top, sight unseen. An artist in France writes: "I'm an American, but for the past several years have been living here in Provence. Although isolation is good for my work, it is bad in the sense that I have no outside contacts, therefore no way of selling my work, feeding my young family, and buying materials. How is an artist in my position without friends or contacts in New York ever to find a gallery to represent him? It's a great enough strain just to produce one's work. . . ."

Well, why doesn't he go to Paris, become familiar with some of the hundreds of art galleries there, and then try to show in one? As for the "great enough strain just to produce," I have never seen an artist who did not much prefer to stay in his studio, who did not hate to have to shop for a chance to show. It is just like anyone having to look for a job—that is the worst job in life. But it has to be done. However reluctant he may be to accept this fact, if he wants to exhibit, an artist must expect to take some time away from his studio work. But he cannot expect to achieve much by sitting home and writing a letter; nor to break into the big-time with no experience or prior acceptance.

Start Modestly

If you study and explore the gallery situation in the city where you would like to show, you will soon recognize the "top" galleries by their looks and size, by the kind of catalogs and announcements they issue, and by the size of the ads they take. If you have not yet attained a reputation, don't go to the top galleries and expect to make the grade—even if your work is in their direction. Being most in demand, such galleries are almost certain to have a full roster. When they do have an occasional opening, gallery directors are more likely to "steal" some artist from another, smaller gallery, where that artist has already made some reputation.

Explore the smaller galleries. There is nothing degrading about showing in a small gallery, or in a gallery which is "off-beat" and not in the geographical area of the top galleries, provided it operates within the accepted professional requirements.

Gallery-hopping is understandably a great outdoor sport for artists, for it is one way to get ahead and move from the lesser to the better-known gallery. Exposure is important: it is much better to show in a modest gallery than not to show at all. If you are successful there, you may be invited to move up.

A gallery which is newly forming may be worth looking into, for the dealer almost certainly does not yet have a full roster. It is impossible to predict how well he is going to make out or how long he will stay in business. But if you have a chance to talk with him and to gain impressions about his judgment and his taste in selecting his artists; and if you feel that you could have a good rapport with him, then you have little or nothing to lose by trying such a gallery. Many lasting relationships have developed between dealers and artists who started together on the ground floor. If the relationship doesn't work out and you must look elsewhere, at least you have built up some experience. Dealers, like artists, often start in a modest way. Then, if they are successful, they move into larger quarters in better art neighborhoods, taking their stable of artists with them.

Check the Reliability of New Dealers

Artists naturally like to check the reliability of new dealers, particularly when they are asked to send their work to a dealer who is about to open a gallery somewhere remote from the artist's resi-

dence. Many such dealers from various parts of the country come to the Art Information Center to search for new talent. On the basis of the slides they are shown, they go to artists' studios and select work to display. Artists so chosen often call or write the Center to try to learn something about the reliability of the dealer. This is a very difficult question to answer, for there is no Dun & Bradstreet's for art dealer-to-be. I have sometimes suggested that the artist write to the curator of the museum in the dealer's city. The curator is likely to know something about the dealer if this individual has been active in the local art field. New dealers, in or outside of New York, would be wise to provide themselves with credentials, including letters or statements that would convince the Art Information Center and the artists of their reliability. It is probably too much to hope that Chambers of Commerce might establish their own reliability checks in their localities.

4

SHOWING WORK
TO DEALERS

It scares dealers to see an artist entering the gallery with a big package or portfolio of orginal work. Dealers don't want you to set up work in front of the show they have on their walls, for then customers will not know which is for sale.

Take Slides

Dealers can look much more discreetly at slides or photographs than at originals, or projections. If they are interested, they will suggest a time either for you to bring in originals or for them to visit your studio. If you have an unusual technique or combination of mediums which is only apparent in the original, then take along a relatively small original example, as well as the slide or photographic reproductions. Approximately fifteen to twenty slides of your best recent work is a sufficient number to take. If you arrive with boxes and boxes of slides, the dealer will be alarmed at the thought of having to take the time to look at them all. If you take only four or five slides, he will not get a sufficient feel of your style.

The 35 mm. color slide is most commonly used for this purpose. Artists who know little or nothing about photography nevertheless take their own, for it is very much less expensive than hiring a professional photographer—who often does not know much about photographing painting or sculpture. Artists who are strictly amateur photographers tell me that they get the best results by shooting their work outside, in daylight, when the sun is high. Apparently, the sun is the amateur photographer's best friend; artificial lighting is his

Waterloo. I have seen many slides taken in the city showing a bit of roof or fire escape around the edges of the painting. It is a good idea to take two slightly different exposures of the same work when you have it set up; then you can select the better of the two for important use and still have a duplicate set on hand.

You are apt to have various needs for slides: a dealer may wish to keep slides for a day or two for consideration or to show to a partner; you may wish to send some to the Art Information Center for dealers to see when they go there seeking new talent; you may want to submit work to competitive shows or to curators of museums who ask to see slides first. You should have a complete additional set for yourself, for you never know when you may need them or if those you heve sent out will return. As long as you have a full set on hand, you can always have duplicates mechanically made at the photography shop. Duplicates so made will not be quite as accurate in color and will usually cost a bit more than original duplicates, but they will nevertheless serve your needs.

Label Slides and Take a Viewer

All slides and photographs should always be labeled with the dimensions of the work, the medium (if it is not immediately obvious from the reproduction), the title (if you wish to use a title), and your name. These notations should be made on the frame or margin in the direction in which the slides or photographs are to be viewed; thus, you indicate which way to put the slide in a viewer or which way to look at a photograph. Though most galleries and museums have viewers for 35 mm. slides, some don't. Therefore, it is wise to carry some kind of simple hand viewer. A projector which has to throw the image up on a wall may scare dealers as much as a huge parcel of originals, for it is equally indiscreet. There are numerous small viewers on the market; I prefer to use the type without batteries which simply utilizes daylight, for the colors in paintings are more true in daylight, and batteries have a tendency to peter out and make the light flicker. The daylight viewer, the most inexpensive kind, is often hard to find, for photography supply stores prefer to sell the ones that cost several times as much. But I find that with persistence, by placing an order, and then returning to remind the store about my order, I finally can get a daylight viewer. The stereoscopic viewer—which *does* work by battery—is particularly good for sculpture because it best conveys the three-dimensional aspects.

Take Résumé

In many cases a dealer is more favorably inclined toward an artist if he knows that the artist has had some art experience and background. For the dealer understands that it will be easier to convince a vacillating, unsure purchaser if he can point out that your work has been exhibited here and there, has perhaps been selected by some well-known juror or institution, has perhaps won a prize or two, has chalked up some sales.

For this reason, you should hand a brief résumé of your art background to the dealer along with the slides so that he immediately knows that you have had some experience in the field. Keep the résumé brief—a paragraph or a skeleton outline is enough. I have seen biographical material prepared by artists which went into long, flowery descriptions of philosophy and esthetics, making it difficult and time-consuming to dig out any actual facts from the dissertation. Dealers do not have time for all this and they are not interested in your prose style; make it direct and easy for them.

Approaching Gallery Directors

A great many dealers dislike making advance appointments by telephone with artists they do not know. An important patron-customer might walk in just at that time, and then the dealer would be tied down by the appointment. To avoid this, they are apt to say, "We are booked up for the next two years," and that is the end of it; that door is closed to you. But if you just go—without an appointment—to a gallery you have selected as appropriate, you can observe whether the dealer is busy, either with a customer or with hanging a show and, if not, approach him. Do show consideration and tact; if the dealer is busy, go away and return another time. I sent an artist to a gallery that might well have proved suitable for his work; and when he got there, the place was being redecorated and in complete disorder. Nevertheless, this artist approached the dealer who said, "But we are painting the gallery; you can see the drop cloths all over and the mess I'm in; come another time." In spite of this, the artist insisted, "I must see you now because I'm catching a train in forty-five minutes." The gallery director groaned and looked at slides, but it is unlikely that he would have taken on anyone at such a time. P.S. The artist did not get the job.

A certain number of dealers do prefer to make appointments with

artists; if you go to their galleries without advance notice, they are more likely to look at their calendars and make a future appointment than if you use the impersonal telephone. If you have made a trip from some distance and can be in town only a few days, most dealers will considerately make the appointment within the limit of your time span.

Don't spurn a gallery assistant who may ask to see your slides before showing them to the director. A gallery assistant may be a "gal Friday" who pitches in on every aspect of the gallery's work; she is very seldom just a receptionist with no particular knowledge of the field. Assistants are by no means well paid; they work in galleries less for the money than because they have a vital interest in the field. Although they seldom have any final say, their interest and enthusiasm when they take your slides in to the boss could be distinctly to your advantage.

The best times to go to galleries are, naturally, when the directors are apt to be least busy. In many places, Saturday is the big gallery-going day for the public, so is a bad day. On Monday, many galleries are closed. Tuesday through Friday is a better time unless it is apparent that a gallery is hanging a show and preparing for an opening.

Scheduled openings can usually be ascertained ahead of time from the listings of forthcoming shows in the local press or *The Art Gallery*. Look up the gallery and don't go when an opening day is scheduled. Directors are not likely to be in their galleries before about 11:00 a.m. From then until about 2:30 p.m. is, perhaps, a better time than late in the afternoon, when customers are more likely to appear. This advice, however, is a rather vague generalization, for no one ever really knows what a customer is going to do or when he is going to do it.

Establish Rapport with Dealers

No two galleries are alike, and dealers cherish their individuality. So don't say to them, "I understand that all dealers" do this or that. Such generalizations will only get their backs up, and they will immediately point out how they differ, and how they function on their own quite independent terms and ideas. Don't quote to them the generalizations made in this book.

Unless you are really incapacitated, go yourself to see dealers; don't send a middleman with your slides. All too often an artist is delighted to get out of the ordeal when a relative or friend offers to go

for him. But "mid-wives" are not generally welcomed; dealers want to know the artist directly, his thoughts and plans. Rapport between artist and dealer can be very important, but it cannot be established by a third person. Wives frequently say to me, "But my husband must stay in his studio and work; if I can find a gallery that shows interest, then he will go to see them." The trouble with this approach is that any potential interest is nipped in the bud.

Just as in any other field of operation, a letter of introduction or a reference from a mutual friend is, of course, useful in seeing a dealer. But with a dealer who is wrong for your type of work, even a letter is not sufficient reason to show your work to that dealer; when both you and he know your work is not suitable for his gallery, the situation can only be embarrassing.

Some Dealers Are More Sympathetic Than Others

Many gallery directors are genuinely concerned about artists, realizing how many more good artists there are than the gallery space to exhibit them. "I have noticed," said one dealer to me, "how painful it is for an artist to have to go from one gallery to another. But we have virtually no space for a new artist unless one of ours leaves us or we decide we don't want to show him any more. I think this tight gallery situation should be explained to artists so they won't be too disappointed." To allay the disappointment, dealers often suggest other galleries they think are more suitable for the particular artist's work. Actually, it is unreasonable for an artist to expect such referrals; the dealer, busy with his own gallery, has no reason to be informed about the directions of his competitors. Hence, with the best intentions in the world, he may give you "bum steers."

I know one particularly sympathetic dealer who never refuses to look at artists' slides. In order to cope with this task, he asks artists to leave their slides overnight and then puts in many dedicated hours going over them after work. He estimates that about 600 artists come to him each season, many of whom are quite unsuited to his direction.

At the other end of the scale are some dealers who will not look at any artist's work. They have become too discouraged by the great waste of time involved. Most dealers fall between these two extremes and look at work some of the time—especially when there is a possibility that they might be able to exhibit a new artist.

If a dealer shows real interest in your work—and this is not hard to

recognize—but regrets he has no room, then make a note to yourself to return to the gallery during the last half of May. (You might take slides of some new work as an excuse to remind the dealer of your existence.) Most contracts or agreements between dealers and their artists are for the season. If an artist is going to leave for another gallery the following fall, he must notify his dealer prior to summer vacation. Dealers usually make up their following season's schedule before they close for the summer. Even if an artist knows, say, in March that he is going to leave his gallery at the end of his contract, he is unlikely to create friction by saying so until near the close of the contract season. So a dealer is more likely to know about a gap towards the end of the art season than at any other time of the year.

Temperament

Both artists and dealers are widely reputed to be temperamental. Sometimes, dealers may seem more temperamental than artists; perhaps they are frustrated artists who do not have the outlet for self-expression that artists have. But a whimsical, impractical artist can be the bane of existence to a dealer who is efficient and businesslike. The following examples may seem extreme and exaggerated, but they happened not long ago.

A sculptor arranged with a dealer for a show of her work and, after it was installed, she told the dealer that she could not allow anything to be sold because the sculptures all fitted into her luxurious suburban home so well that she could not live without them. It had never occurred to this woman's dealer to require a written statement that he could sell the sculpture. Perhaps he should have, for I have heard a number of artists say, "I am not particularly interested in sales; I just want to have a one-man show and establish a professional reputation." It is a good idea to remember that galleries are "dealing"; they must make a living; they are not in business merely for the artist's own prestige. Dealers, in short, cannot be purely esthetic philanthropists.

A well-known, seasoned artist who had an exclusive contract with an established gallery was invited not long ago to join another, larger gallery in the middle of his contract year. Although he had been around long enough to know better, he blithely accepted the new offer and was chagrined to find that he had to face a lawsuit, which he quite rightly lost.

Precision in Inquiries

If artists and dealers are considered vague, temperamental, and imprecise, certain would-be purchasers can top them any day. How would you answer a note like the one that arrived at the Art Information Center, sent from Connecticut?: "My husband and I are interested in buying an oil painting. We would like something large, approximately 24″ x 36″, or 30″ x 40″, and hope to find one in a semi-abstract or impressionist style at a moderate cost." Or an inquiry from an Arizona motel?: "We would like very much to get information and brochures on large steel figures, true form rather than geometric. We have in mind objects that are over ten feet high."

The inexplicit aspect becomes much more incredible when a professional in the field, the art director of a mid-western institution, can write with such imprecision: "We intend to present a major Art Gallery, in which we hope to display the finest art works available. I hope you will send me whatever information you can provide on the many aspects of Contemporary Art. Our gallery intends to exhibit the finest Art of a local, national, international nature and I eagerly await your reply." Even the Queens housewife contemplating her first art purchase was much more direct and to the point. Should she buy "a beautiful hand-painted head of a gypsy, all framed, for $75? I like it," she said, "but I want to know whether it will increase in value in a couple of years."

Whether you request information from the Art Information Center, from a gallery or museum, from a foundation, or whatever, you can expect a sensible, informative reply only if you state your queries in a specific and sensible way. Know exactly what you want; ask for it simply and clearly. You'll be gratified by the response.

5

BUSINESS TERMS
AND AGREEMENTS

Always get a written receipt for any original work you leave on consignment with a dealer; asking for a receipt is not a reflection on his integrity, it is simply good business. This receipt is your *only* proof—otherwise it is your word against his.

Receipts and the Law

In New York State, a law was passed in 1966 (amended in 1969) against absconding with any work of art, or the proceeds of sale, for which the artist holds a receipt. Under this law a dealer can be prosecuted by the District Attorney for larceny if he wrongfully withholds an artist's work, or the proceeds of sale, left on consignment. Even if the dealer has left the state, he can be extradited for prosecution. Of course the enforcement of the criminal aspects of the law depends upon the functioning of the District Attorney, whose calendar is often loaded with cases he may consider more pressing than art.

Nevertheless, this law takes a big step in the direction of protection for the artist, and New York is the first state to pass such legislation. Hopefully, art organizations, artists, dealers, and museums will press for legislative action throughout the nation. Meanwhile, if you have trouble in New York State with a dealer who has disappeared with your work, get in touch with your local district attorney or with the State Attorney General's office, 80 Centre Street, New York, N.Y. 10013. If you encounter difficulty with a dealer anywhere in the country who is a member of the Art Dealers' Association, its legal

division will give prompt attention to your complaint, for this association is most anxious to maintain a good public image.

Insurance

When you consign work to a dealer, ask him what insurance value he can place on it. Some dealers carry no insurance on work while it remains in the gallery, leaving this responsibility entirely to the artist. But many galleries insure for a percentage of value, covering only the time during which the work is on their premises. A great many artists carry inland marine policies on their work so that, even though they are unlikely to have full-value coverage, they do have some additional protection on their own. The policy can insure wherever the work is—in studio, gallery, friend's house, or truck.

If you know for how much the dealer will insure your work while it is in the gallery (often he will write this down on your receipt), then you can decide whether you wish to carry more or less supplementary insurance yourself.

Art thievery has increased alarmingly in recent years, and insurance is proportionately harder to obtain. Reportedly there are international rings of organized bandits who know profitable outlets for stolen works of art, often in other countries. We have heard that they are even instructed by purchasers to steal particular works. We have all seen many news reports about these thefts in cases of famous art.

What is less recognized is that inexpensive works by relatively unknown artists may also be victims. Insurance companies generally will not cover any art shipped through Kennedy or O'Hare airports because of their high incidence of thefts. Even a work labeled "insured for $100" (packages are required to be labeled on the outside with value of contents) may be taken for the few dollars it could bring on the "hot" market.

It is still possible, however, to obtain art insurance in most areas outside major centers like New York and Chicago. Moreover, the entire theft situation may improve—and with it the insurance picture—if the International Art Registry Ltd. succeeds in "fingerprinting" enough works of art, using an ingenious coding method described in Chapter 6 on copyright and registry.

Transportation

Shipping and cartage costs are almost always the artist's responsibility. Of course, in many cases the solution is simply a matter of bor-

rowing a friend's stationwagon. But when work must be sent to exhibitions and competitions, the shipper's costs both ways must usually be paid by the artist. In addition to regular air freight lines, the three major firms used are the Post Office, United Parcel Service, and Railway Express Agency. It is wise to do some comparative shopping among them all to discover which serves best your particular needs and the areas involved. On the other hand, when a dealer in Montreal, for example, wants to show work by an artist in New York, he may well offer to pay transportation either both ways or one way. How many concessions he is willing to make depends on how eager he is to show the work. If a dealer is anxious to import large or heavy material from abroad, he may have to split shipping costs, which might otherwise be prohibitive for the artist.

Sculpture Bases, Frames, Installation

Although many dealers supply all, or at least some, of the sculpture bases needed, virtually none supply or pay for frames. This practice is quite logical and understandable from a practical point of view, for a dealer who regularly shows sculpture will have bases on hand; whereas an artist who shows paintings has usually already framed them. Most installation costs are carried by the gallery. But if the nature of his work requires unusual or special equipment, the artist may be expected to bring it from his studio or to pay at least part of the cost of having it constructed.

Commissions

There are still galleries around the United States whose regular sales commission rate is 33⅓%, but they are becoming fewer and fewer. Most galleries, especially those in New York, charge 40% on painting and sculpture; 50% on graphics or other work executed on paper. Like everything else which has increased in price, dealers' costs have risen and so have their commissions. Be prepared, then, to pay these commissions to your dealer on sales. If you find a reliable dealer who charges less, you are just lucky. Some dealers, who take care of part of the costs usually billed to the artist, take a still higher percentage. The few gallery directors who still charge a 33⅓% commission usually have to make up the difference in various additional costs to the artist. In most cases you can't win.

Work Left on Trial

Most dealers take work by living artists on consignment. This means that whether you are asked to leave work on a trial basis, for a group show, or for a one-man show, the dealer pays you nothing until the work is sold.

Remember that most established galleries are booked quite far ahead with one-man shows of work by their roster of artists. Probably the best they can offer you at first is the opportunity to leave a few things on trial. A dealer can properly handle only about two dozen affiliated artists because he is expected to give each of them a one-man show every two or three years, as well as hold two or three group shows of their work each season. This obligation fills the art season calendar, which runs, roughly, from late September to early June. If the dealer takes on too many artists, he cannot do right by them or their needs for exposure.

One long-established New York gallery found itself in a real predicament because its owner was too generous about taking on artists. When the owner died and his heirs took over, they found a roster of forty artists—meaning that each one could have a show only about every four years, which is just not enough exposure for an artist who has "arrived." The new owners frankly explained their dilemma to the artists, urging them to try to find other galleries. They offered to help their artists in every way possible and to continue to represent and back them until they could find outlets able to give them better and more frequent attention.

Even if you have previously held exhibitions elsewhere, a dealer generally wants to see how his particular clientele reacts to your work. If the dealer takes work on trial and sells some in two or three months, he will doubtless ask for more; if not, he will probably suggest that you take it back. He may not even hang it or show it publicly; he may have some particular customers in mind to invite to see the work in the gallery's back room. This way of proceeding can be of distinct value to the artist, for many of the best sales are made in the back room. Good customers can influence a dealer's decision about acceptance; sales often lead to a request from the dealer for more work to show out front.

Group Shows

In addition to the annual group shows of work by their regular artists, many dealers also hold group exhibitions of "guest" artists

whose work interests them. These shows, frequently scheduled for off-peak seasons such as late May and June or early September, are also a kind of trial run to see how the new work will be received.

A number of member galleries of the Art Dealers' Association began in 1973 to hold simultaneous New Talent Festivals annually in early June. Those galleries choosing to participate, pooled their efforts towards publicity and advertising through the Association as a clearing house: one mailing piece designed and printed for use by all the galleries across the country; one large advertisement in the Sunday *New York Times* art section. Some, though not all, agreed to publicize in art magazines ahead of time the fact that they would make appointments to see slides of artists who had not previously had any one-man shows in a major art center.

Most participating galleries tended to show groups, with a sprinkling of one-man new talents. In either case, there were no commitments to the artists of continued representation by the exhibiting galleries, although there have been instances where artists were taken into the gallery's roster. But to be picked by one of these top-ranking galleries even just once is a distinct asset in your favor. Unfortunately, these shows did not take place in 1975.

In any group show the work is definitely "out front" in the gallery. Moreover, the show is often publicized by the dealer; occasionally, there are some press notices about it. Success with such new work, in public and press response and in sales, can mean that you will be taken into the gallery's roster as soon as the next opening appears.

The artist who is asked to leave work either on trial or for a guest group show should not stop there. It is a good idea to continue to see all the galleries that you have analyzed as suitable for your work. Dealers who have your work on trial do not expect exclusivity. You are completely at liberty to show elsewhere at the same time, without building up any prejudice by so doing. You may get additional similar opportunities, thus achieving more exposure, and quite possibly more sales and recognition. Furthermore, you may thus have a chance to see which of several galleries works best with your particular art form, and which has the better clientele for it.

Dealers will object, however, if you permit price undercutting by another gallery, particularly in the same geographical area.

One-Man Shows

Once you are asked to have a one-man show, the dealer doubtless wishes to consider you a regular member of his gallery's stable. Oc-

casionally, there are guest one-man shows; but this is a rare event, for dealers are more apt to reserve this top recognition for artists who are definitely affiliated with them through some sort of contract or verbal agreement.

If you accept a dealer's offer of a one-man show, he will then probably expect you to pull in your work from other galleries and make an exclusive agreement with him.

Contracts

It doesn't matter whether a contract is printed in legal language, is made through an exchange of letters, or is verbally agreed on. In all cases, the contract is considered binding. One highly reliable dealer in New York wrote to me: "I have found that it is best to deal with artists on the basis of mutual understanding and trust. I do not believe in 'contracts' because a contract is only as good as the two people signing it. Since I would never sue an artist in court, I would not find a contract meaningful. However, for the artist's protection of his work, I insist upon giving the following agreement to each artist when he first joins the gallery." And there follows a pretty comprehensive set of arrangements.

Particularly for a newcomer, it is more satisfactory and protective to have something in writing. If your dealer has no contract or agreement form and you have merely discussed the terms of your agreement, go home and write a letter outlining what you feel to be your understanding of the agreement. Keep a carbon copy for yourself. If you have misunderstood or misrepresented any terms in the letter, the dealer will surely let you know the corrections. Keep these documents as your binding agreement.

Read every word of anything you sign. Some artists, elated at the thought of obtaining a one-man show or shy at the thought of seeming to doubt their "benefactor" dealer by scrutinizing the papers, have later found out some sorrowful factors to which they have bound themselves legally. Most good dealers will have more respect, not less, for the artist who takes time to go over a contract carefully, ask questions, and clarify points.

Artists' Equity Association, Inc., issues a form contract, a receipt form, and a bill of sale for the guidance of artists. You would do well to scrutinize these models. They are available free to members from the Association's headquarters (2813 Albemarle Street, N.W., Washington, D.C. 20028). Keep in mind, however, that these forms

are drawn up primarily from the point of view of the artist. Certain of their terms—such as complete coverage by the dealer of all costs of a one-man show, and full value insurance by the dealer—are rather more idealistic than realistic, for they are rarely achieved. For a typical contract form, see Chapter 16.

Terms of Contracts

Terms of contracts or agreements should cover the following:

Length of period during which the dealer is to act as your sales representative: This is usually one year. Some dealers, however, prefer two-year agreements when the artist is relatively unknown. They feel that investments in publicity and groundwork laid during the first year do not pay off until the second.

Percentage commission to gallery on sales: This is generally 40% on painting and sculpture, 50% on graphics, in the large art centers, but there are some areas where the old 33⅓% commission is still retained. If the commission asked by a dealer is less than the normal going rate, scrutinize other terms and costs to make sure that you are not paying too much out of pocket to make up the differences in the commission. A gallery which asks only 25%, for example, may not base its business on making many sales, an arrangement that is not to your benefit. A gallery asking a low commission can be even more suspect than a gallery which charges more than 40%. A few of the country's larger galleries which handle high-priced, well-known artists charge up to 55%. However, these galleries then take care of all costs, of widespread promotion, of show distribution, and of other activities for their artists.

Some contracts spell out the usually accepted agreement that the dealer receives no commissions on prizes or awards granted to the artist, but does receive commission on a purchase prize. Charitable sales are generally exempt from commission unless the artist has received his full price. Full price payment is unusual, for the soliciting charities customarily request that the artist split the sales price with them on a fifty-fifty basis or perhaps with 75% going to the artist. With the increased cachet of contemporary art in the world of society, these requests from charities have become so numerous in recent years that many dealers have clamped down on granting any of them—not only because they receive no commission on such sales, but also because they feel that their artists are being victimized. For the charitable organization ladies are all too prone to take the atti-

tude: "We're not asking you for money, just for some of your work," with no apparent realization that an artist's work is his livelihood.

Sometimes an artist is taken in unwittingly by an "invitation" to enter a show, inclusion in which is presented as an honor. An artist friend of mine recently answered such an invitation from a well-known print club which said it had obtained exhibition space in an established New York print gallery. The invitation did not mention commissions. He sent a large engraving which he priced at $45. Soon he was notified that it had been sold. Later, he received a check for only $15, along with a statement that the gallery had taken one-third and the print club had taken another one-third. He said he certainly would never have sent the print had he known he was inadvertently making a "charitable" contribution to the well-established print club.

The case of contributions of work to an art sale for a politician's campaign fund is entirely different. Dealers are not apt to intervene in an artist's political views or activities. And there are no proceeds at all to artist or dealer if an artist donates work for this purpose. For it is against federal law for anyone other than the campaigner to receive payment from any political campaign activity. The donation must be complete and total.

Extent of exclusivity: By geography, exclusivity varies according to the gallery's outside contacts. Often the exclusivity required is just for the city and its environs; you are free to show and sell anywhere else without paying your dealer a commission. Often, however, exclusivity covers the whole of the United States. Sometimes it is world-wide—particularly if the gallery has branches abroad or exchange arrangements with foreign galleries. Geographical exclusivity does not mean that an artist cannot show elsewhere. Out-of-town shows are often arranged either by the dealer or the artist. In these cases, your dealer must agree to the exhibition, and the out-of-town dealer must agree to give credit in the catalog to your dealer and to split the sales commission with him, which means no extra charge to you. Your dealer invariably expects you to pay him his full regular commission on sales you make from your studio, or on any other sales without the assistance of the gallery. You may give work to your friends, but you may not sell to them less the dealer's commission. Perhaps you wonder why. It is apparent that sales are definitely related to reputation, and your dealer, by showing your work and having your name promoted in connection with his gallery, has

presumably enhanced your chances for sales. Moreover, many a dealer has found out by sad experience that both collectors buying and artists selling are all too prone to bypass the dealer's commission, no matter how much work and effort he has expended.

Exclusivity terms may also specify mediums. That is, many galleries make exceptions in their totality of representation for work such as prints or other multiple productions. If their own chief interest lies in your major work, they do not want to take up time and space with many less expensive items. In such cases, they are quite willing to state that you may also be represented by a print or multiple gallery. Occasionally, galleries also waive their rights to small works; for some years there was a gallery in New York for small paintings and sculptures only, every member of which must also have another, "regular" gallery in order to belong. This, of course, meant that the regular gallery had given permission in each case.

Time of one-man show: The length of your show should be stipulated in your contract or agreement. Normally, a one-man show should run for about three weeks. Dealers have learned by experience that it takes about this long for the show to pay off after it has caught on. Sometimes dealers suggest 10-day shows, usually because they want to make at least part of their income from a fast turnover of fees from artists, part of which may go into their pockets instead of into legitimate costs for the artist.

Frequently the date, or at least the month, of the show is also stipulated. The usual times for scheduling one-man shows are October and November, and from January to mid-May. In December, most dealers have group shows of work by their affiliated artists, exhibiting small pieces, watercolors, prints, drawings—items likely to appeal as Christmas gifts. Now and then some expensive artists have refused to have their shows in January or February on the theory that too many well-heeled collectors are off in Florida at that time. But very few people feel that this is a serious consideration, particularly in view of the fact that nowadays winter vacations are taken just about any time during the season.

Many agreements also mention that, in addition to the one-man show, your work will always be represented in each gallery group show, and that a few works will be kept on hand, at all times, in gallery bins.

Prices and payments: Frequently, contracts state that after sales prices have been mutually agreed upon, nothing will be sold at a lower

price without the artist's consent. Frequently also, it is stipulated that the money received by the dealer from sales is held in trust, and that payment will be made in a reasonable time—perhaps fifteen days after final payment, perhaps regularly once a month.

Commercial use of art and reproduction rights: Commercial uses of works of fine art are becoming more and more frequent. Artists and dealers, therefore, are increasingly aware of the need for protection. It is now fairly common for dealers to stipulate in their agreements with artists that they will at no time sell an artist's work with reproduction rights for commercial use unless such rights are additionally purchased, and then only with the artist's permission. Thus, if an artist does not wish to see his painting decorating an insurance company's promotion calendar, he can refuse to allow its reproduction even though the insurance company has purchased the painting. If he does not object to this arrangement, he will receive royalties or some other additional reimbursement. Most dealers now require a purchaser, commercial or otherwise, to sign an acknowledgment that the sale is made only on the understanding that all reproduction rights still belong to the artist. If the dealer has arranged the sale, and if the artist gives his consent to reproduction, the dealer will expect 10% to 20% commission on any additional funds.

These understandings and agreements may well be spelled out in the contract. If the artist made contracts for reproduction payments prior to any gallery agreement, the dealer should not cash in on them; but in this case you had better see that the dealer contract states your rights to the full amount of these reproduction fees.

There are cases, such as for educational uses, when charges for reproduction rights are waived by the artist and his dealer, who are glad to help some professor illustrate his textbook. I see no reason why a modest charge should not be made even for educational books, for, though not on the best-seller lists, they often sell steadily for years. But this decision is entirely up to the artist under the usual contract clause covering this contingency.

Although in recent years these protections have become fairly widespread and have been fostered and promoted urgently by such organizations as Artists' Equity, they are still not as accepted as artists might wish. In New York State, the Act of September 1, 1966, states: "Whenever a work of fine art is sold or otherwise transferred . . . the right of reproduction is reserved to the grantor . . . unless expressly transferred in writing signed by the owner of the rights. . . ." This kind of legislation also needs to be more widespread.

Expenses: In addition to suitable framing, some transportation costs, and insurance expected of all exhibiting artists, the contract usually states that the artist must pay all publicity expenses—but for a one-man show *only*. These expenses will probably be the largest of all (they are likely to come to a minimum of $600 in New York). But you are not apt to achieve a one-man show until you have already sold work left on trial or have exhibited in a group show (where you should not pay for publicity). Consequently, you probably won't have to face the publicity costs of the one-man show until after you have collected some funds to defray them.

Publicity costs usually include advertisements, a brochure with some reproductions, mailing charges, photographs for the press, and in some cases, an invitation and preview. Charges should not include rent, light, heat, or secretary's salary. You should be able to see the actual bills for these out-of-pocket expenditures, to know just where your money went, and that it did not go into the dealer's pocket as a fee.

In many cases, the dealer will consult the artist's wishes regarding publicity and will accordingly place larger or smaller ads, prepare an elegant or simple brochure, and cut down on or eliminate the preview to accommodate the artist's pocketbook and desires. But in many other instances, dealers have contracts with publications for ads and these must be fulfilled; they have a regular size and format for brochures to be published in similar form as a kind of "signature" of the gallery; they have a standard form of preview. In such cases, you are not in a position to dictate or argue; you have to take it or leave it, for the dealer is privileged to run his gallery as he sees fit. If you cannot afford the particular dealer's outlay on publicity, then you must try to get another dealer with a less "elegant" approach. The contract generally demands these payments in advance, so you cannot wait for sales from your one-man show to cover them.

There is a very wide range in outlay for publicity among galleries, depending on the individual dealer's practices and potentials. What the artist must pay for publicity also varies according to his reputation and his sales record. The better known and the more financially successful you become for yourself and your dealer, the more likely he is to absorb at least some of the costs.

Contracts frequently state that the dealer agrees to pay for packing and shipping work to clients, and mentions the percentage of total value he is willing to insure for, against loss or damage in the gallery only.

Cancellation of agreement: Most contracts are binding to the end of the stipulated period. At that time they may or may not be renewed by a further agreement. Some dealers, however, state that the contract may be cancelled by either party with a stipulated amount of notice, provided that printing for a show has not already been done and advertisements have not already been placed.

Preliminary Arrangements for a One-Man Show

Once the contract is signed, your dealer will probably come to your studio and select the work he wants to include in your show. Usually, he will discuss the selection and be guided by your judgment, as well as his own. I have known of cases, though, like that of an artist noted for his sculpture, who also wanted to exhibit his paintings. The dealer refused, feeling that the artist was inferior in his more recently developed medium and believing that showing this work would only be damaging to both their reputations. Some years later, in another gallery, the artist had his way; the general critical evaluation indicated that the first dealer had been acute in his prediction.

You may have to send most of your exhibition items to the gallery a month or six weeks before its opening so that critics of the art monthlies can preview them. Critics must see work this far in advance if their reviews are to appear at the time of your show. Most reviewers do not have time to go to studios. If the gallery is cramped for storage space, you may have to take the work back to your studio again until time for its installation. Although your dealer will have a mailing list not only of press, but of customers, he will undoubtedly request your own mailing list of friends and collectors or will ask you how many additional brochures you want printed to send to your mailing list. In many cases, artists mail out their own lists, often adding notes of a personal nature to the brochure or announcement mailed.

Your dealer may wish to expand somewhat your brief résumé for biographical information to appear in the catalog and press release, and to use any good quotations available from your reviews. He will expect you to provide quality 8″ x 10″ glossy photographs of a half dozen works to be shown, perhaps with three or four copies of each. For this purpose it is probably advisable to use a professional photographer. The photographs will be mailed to a few selected publications in hopes that they will be reproduced; others will be kept at the gallery for critics who may come to your show.

Critics and Reviews

Critics are people whom everyone shakes a fist at, except on the rare occasion of a good review. Not that critics always, or even most of the time, write bad reviews; it's just that they don't write any at all about so many shows. There are too many shows and too few critics.

How to get on their priority list is a chronic dilemma. Many different approaches are tried: irate letters to the editor; needling telephone calls to the art department; a plethora of photographs and other material bombarding them in the mails; pleading and wheedling, excoriating and threatening. Critics nevertheless go their way, probably with no priority lists at all and with no regard for these numerous appeals. Often it is apparent that to some extent they go their way geographically, for reviews of shows will appear on galleries which are geographically close: one may assume that critics' feet get tired too. No matter how critics select what they cover, there are always many artists and dealers who are certain that their shows were far more worthwhile and deserving than those reviewed. Old-timers consequently tend to relax, shrug their shoulders, expect nothing. If a review does happen to appear, it is a great and unexpected event. Wherever you are, in large or small city, it's a good idea for you or your dealer—but not both, and preferably the dealer—to call members of the art press well ahead, to ask them when they would like to have an advance viewing and whether at the gallery or the studio.

Many publications carry listings of openings as an editorial service, not paid for as an ad. Usually, it is not hard to get a show listed if the information is sent before the deadline; and these listings, even if they make no critical comment, do help to guide people to your show. There are some little publications which will carry reviews if the shows are advertised in their papers.

You should put copies of whatever write-ups you get, along with other printed material such as brochures, announcements, and press releases about your work, into a portfolio. You never know when you may want to approach another dealer; although some dealers want only to look at work, others do want to see such records when considering the possibility of handling your work. Some dealers like to keep portfolios of this nature in the gallery to show to prospective customers and to visiting press.

Installation and Preview

Dealers often welcome the assistance of the artist in installing a show. Time is very short: in a typical situation, the previous show closes on Saturday at 5:30 or 6 p.m.; your show opens on Tuesday afternoon. All dismantling and disposal of the previous show, refurbishing of gallery walls (nail-holes, paint scratches), as well as complete installation and labeling of your show must be done on Sunday and Monday. Occasionally, however, a dealer has his own special way of working or a special display technique, preferring to install the show by himself, with assistance from just his own staff.

For your preview there may be a party at which drinks are served, but just as often there is no party. Because Saturdays are the biggest gallery-going days for public attendance, some dealers who do not wish to hold parties or stay open into the evening simply announce that their new shows will have their openings on Saturdays, throughout the day. In some cases, geography plays a part in coincidental openings; galleries agree to co-ordinate them to make it easier and more appealing for gallery-goers, enabling them to see several shows in the same area.

When parties are held, the preview costs may include overtime for an elevator operator and perhaps the hiring of a bartender, though more often the latter capacity is filled by a gallery assistant or a friend. Hard liquor and snacks are sometimes served; sometimes just a glass of sherry or wine. The party has become something of a problem because of the "floater" and "hanger-on" element which drifts from one gallery party to another just for free drinks. There is actually a firm in New York which, for a "subscription" fee, will tell you by phone where free drinks are being served tonight. Frequently, when leaving a gallery opening, you will hear someone announce, in an elevator full of gallery-goers, "They are serving hard liquor at such-and-such gallery." Naturally, both dealer and artist would prefer to be delivered from the floater elements and the costs incurred by them, as well as the beatnik atmosphere often imported by them. Some galleries wishing to hold parties issue invitations which must be shown at the door; others avoid the problem by serving nothing. In the latter case, it is not uncommon for the dealer or the artist to invite friends to cocktails or a buffet supper, at home or in a restaurant, thus entertaining only those to whom they wish to give official recognition.

Commissions for Mural, Portraits, Architectural Sculpture, Monuments

Alert dealers always keep an ear to the ground for possible commissions for their artists, and many have mailing and telephone lists of architects and interior designers to use when appropriate. But don't count on it. If you know any architects likely to commission sculpture, murals, or monuments in a vein that harmonizes with your work, check with your dealer to be sure his list of contacts includes those you know.

Look in the library at recent copies of the architectural magazines to see which architects have used in their constructions the kind of art you might supply; consult the *Dodge Reports* and the city building commissioners for new plans in your area and which architects are participating in them. Don't go to them directly unless you first arrange to do so with your dealer, for you then might duplicate and interfere with his efforts, and he would be justifiably angry. Once you have a dealer representing you, it is always you who must check with him before making any move aimed at contacts for sales. For this is his province, so he is expected to go about his business without checking with you.

Periodically two or three architects from an important firm "go shopping" in galleries for art to enhance a new building project. Such a visit usually puts the dealers into a tizzy of delight, with great hope for "something big" to result. It is amazing how small the big art world can be. Word of these visits usually spreads like wildfire, and the architects are bombarded with calls from dealers not visited: "Please come to see my artists."

A number of galleries have developed in the cities especially to serve the interior design and decorator field. Some of these dealers have their own rosters of artists, give one-man shows, and operate as regular galleries. Others show work by artists with different gallery affiliations, split commissions on sales, never give one-man shows, and concentrate on placing work in "the trade." Many also show unaffiliated artists, but these galleries ask no exclusivity. Frequently these specialty dealers sell in quantity—for example, to a firm buying a painting for each office on three entire floors of a new, large office building. They also obtain mural commissions for new hospital wings and new apartment buildings through working with the interior design consultants for the buildings.

Apparently not all such consultants always consult. In one instance, a large abstract mural was commissioned for the entire length of the lobby in a new apartment building. Two weeks after installation, the landlord appeared for the first time, gave forth the edict that it was horrible, and ordered it completely covered with canvas. The tenants then complained bitterly: they did not like canvas, they did like the colorful abstract mural. The tenants won. The canvas cover came down. The artist had already been paid; even so, he naturally was much happier to have his work seen and to receive "popular" backing for it.

Many of the firms selling furniture and interior accessories also welcome the opportunity to display some paintings and sculpture suitable to their line. They may borrow from art galleries and refer purchasers to them, asking no commission. They may show and sell work by unaffiliated artists if the work seems to have a rapport with their display rooms. Price labels are attached so their customers know the art is for sale; and when they sell, they take only a small commission, such as 10%, for handling costs. If these displays lead to commissions, the artist usually takes over on his own, with a nice "thank you" to the furnishings firm. Sometimes interior decorators make purchases for their clients directly from an artist who has no gallery agreement; payment in some instances may be very good.

Although it is often the architects themselves who commission architectural sculpture and murals, some years ago they apparently were at a loss to know how to go about this. One well-known head of a large architectural firm called me about a huge sculpture he wanted to place outside a high-rise office building; it must be big enough not to look dwarfed by the building. Where could he go to see work from which to select? Since this obviously called for a sculpture several stories high, I pointed out to him that he could scarcely expect to find already completed work in sculptors' studios, that he would have to commission such a piece. He could start with several sculptors whose work seemed suitable and ask for a maquette from each. Of course, he must pay for all the maquettes; but then he could choose the one which looked best beside the scale model of the building and commission that one for execution, with no further obligation to the other artists who submitted maquettes.

Today architects are much more aware of these procedures, for it has become *de rigueur* for buildings of any importance to contain

works of fine art. Moreover, museum curators in recent years have often aided architects in these matters, in exchange for a tax-deductible contribution to the museum. The American Federation of Arts offers a regular consultant service of this nature to architects and business firms of all kinds.

These practices have been questioned, particularly by Artists' Equity, because such a "tastemaker" position opens up possibilities of a "favorite" list of artists to be recommended, of conflicts of interest in personnel, or the art collections of trustees and curators which would increase in value were the same artists to receive important commissions. Yet—in the past at least—these activities have helped to spread commissions among many artists; formerly there was a great tendency to employ the same ones over and over. A firm desiring a sculpture on its building was loathe to stick its corporate neck out in a field unknown to it, and hence would hire the same sculptor already used by other firms because he seemed "safe."

The Business Committee for the Arts, with former Secretary of the United States Treasury, C. Douglas Dillon, as its first Chairman, was established in 1967 to act as a catalytic agent between business firms and the arts. A good deal of its attention focuses on the performing arts. However, the Committee manifests considerable interest in corporate collections and art commissions, as well as grants to foster art in public places.

Here and there specialized dealers have organized displays and files of reproductions expressly to serve as clearing houses for business and industry to consult for their needs.

Further developments relating business and the arts are sure to be a part of the future. If these potential opportunities interest you, follow the local press to learn what is happening in your geographic area. These developments will undoubtedly be publicized and reported. The firms involved will see to that: they have energetic publicity offices, and they are good advertisers.

There are various organizations which help artists to obtain commissions. One is the National Sculpture Society, 75 Rockefeller Plaza, New York, N.Y. 10020, which holds competitions and exhibitions (especially of architectural sculpture), accepting work by nonmembers for some of its shows. Another is the National Society of Mural Painters, 41 East 65 Street, New York, N.Y. 10021, which holds biennial exhibitions and gives prizes to young artists for work related to architecture. The Architectural League of New York puts

on frequent shows also in the building of the American Federation of Arts, 41 East 65 Street, displaying work related to architecture, city planning, and subway station design. Portraits, Inc., 41 East 57 Street, New York, N.Y. 10022, is a gallery with a roster of artists specializing in portrait painting; in addition, the gallery also acts as agent for mural commissions.

In spite of the enormous invasion of photography into the field, portraits in the various mediums are still commissioned quite frequently. Although many galleries show occasional portraits along with other kinds of work by their artists, and Portraits, Inc. specializes in this field in New York, it is probably a safe guess that portrait painters and sculptors obtain more commissions on their own than they achieve through dealers. Portraiture is a field which is perhaps more self-generating than any other; because of the personal nature of the portrait, the satisfied subject is apt to become your best salesman, and one commission tends to lead to another.

The Dealer's Percentage

The percentage charged by dealers on outside commissions varies considerably, usually in proportion to how much the dealer contributed to obtaining the commission for the artist. If he was entirely responsible for it, he will probably expect the same 40% as on other sales. If he advances cash to the artist to enable him to work on the commission, he may expect 50%, as in other situations where the artist receives an advance. In some cases, where there are exceptional costs to the artist for materials or assistants, the dealer may take less or he may base his percentage on the net amount of the commission after expenses. If the artist obtained the commission entirely on his own, his dealer may expect only 10% or 15%, though in some cases galleries require 33⅓% on all commissions, regardless of their role.

Special Portfolio

If you want to work on commissioned projects, you will be wise to prepare and keep a special portfolio up to date. This portfolio should contain reproductions of commissioned work already executed (if any), as well as of proposals, sketches, maquettes, and other pertinent material, including portraits if you are a portrait painter. If you

cull this specialized work from your total output, you or your dealer can use the portfolio as a presentation.

Reproductions

When commercial firms purchase works of art along with reproduction rights (providing the artist consents), they often do so for product advertising or for use on prestige promotion pieces to be given away. In either case, they are more likely to buy these rights from the artist on the basis of an outright sum rather than with royalty, a sum which is perhaps double or triple the price of the original work.

If they are buying reproduction rights for a work belonging to a museum whose name will appear on the reproduction, the museum's permission as well as the artist's must be obtained. Both the museum and the artist should have the right to see its preliminary layout and copy to determine whether the presentation will be sufficiently dignified before agreeing to its use. Many artists and museums object to the imprinting of any copy over or intruding into the reproduction of the work of art. Many insist on at least a thin strip of "frame" around a reproduction of a painting, unless it is a detail where there is more of the painting beyond the "bleed" edge. Paintings are conceived in general to be within frames, so your composition will be destroyed if a reproduction of it does not enclose it properly. For reproductions of sculpture, this does not apply, and they are sometimes best shown in silhouettes.

Both the artist's and the museum's names should appear in conjunction with the reproduction, and on the same page, not in a credit box somewhere else in the publication. Because such uses are usually predicated on the prestige value of the museum's name, and because museums are proverbially in need of funds, the museum frequently requires the firm to pay to it a sum equal to that paid to the artist for these rights.

On the other hand, payment to a dealer who makes such an arrangement for you would perhaps be only 15% to 20%, for a business firm is not interested in buying the use of another business name. When reproduction is for strictly commercial purposes, the fee can go much higher than when for illustration. Use on a coal company's calendar should normally cost more than use in a newspaper's Book Review Section.

Reproductions in Periodicals

Of course no charge is made in the event that reproductions are to be used in conjunction with a critical review, or for other publicity purposes which are eminently to the advantage of the artist. Indeed, your dealer should make every effort to have your work reproduced free of charge as often as possible in art columns, catalogs, journals, and books. Without question, such reproduction actually raises the value of the work of art and the status of the artist.

However, some periodicals tend to exploit the concept of "publicity" for the artist, when actually they wish to use reproductions of works of art primarily as free illustrations for texts not related to the artist. They don't want to pay or commission an illustrator for the job; in order to avoid paying an artist for reproducing his work, they will argue that the name credit they give him is sufficient reward because of its publicity value—a very dubious premise. The more reliable periodicals, however—such as *The New York Times* Sunday Book Review Section—have long since established the precedent of paying an artist at least a small fee for using his work to illustrate their articles. Here again, it should be ascertained that the reproduction will be used in a dignified context and that credit to the artist will appear on the same page as the reproduction. Surely if more artists and their dealers, as well as more museums owning work by living artists, continue to demand fair payment and credit, the reproduction field will cease to be the racket it used to be and will supplement the incomes of some artists.

Getting Published

Many artists are interested in getting their work published by reproduction houses which then market them. Some hope for publicity and income from this source; some seek to fulfill numerous demands for the same picture.

Framable-size reproductions are a big-time operation, ranging from famous old masters to virtually unknown contemporaries. Large supply printers take works of art for publication on the basis of their own judgment as to what they believe will sell. Commitments are made at their own risk as far as costs are concerned. They are in business; they are not philanthropists or estheticians. They aim to satisfy all public tastes, and their boards of selection pick for appeal

value rather than for established reputation of the artist, whether in the old master or living artist field.

Reproduction fees paid to artists vary considerably, depending on size and price of reproduction, distribution and promotion potentials, and the publisher's guess as to saleability. An unknown artist may well get as much as one with reputation. Large publishers seldom pay royalties because the book-keeping would be too complicated; instead they pay a flat fee for rights to a limited edition. This assures the artist of immediate payment of a specific sum and removes his need to check any sales figures. The edition may be agreed upon as, say, 1,500 or 3,000; should it sell out, and the publisher wants to re-issue, he agrees to obtain further permission from the artist to pay an additional fee, usually the same as the first payment.

Reputable firms offer you the right at any time to inspect their books as they relate to your account, in the same manner as the Internal Revenue Service which must be able to view books at will without notice. Thus you run no risk that the firm might overrun the edition or misconstrue total sales. All reproductions should be copyrighted. You must have all these arrangements in writing.

One of the largest art reproduction publishers in the U.S. of framable-size works of art is: New York Graphic Society, Ltd., 140 Greenwich Avenue, Greenwich, Connecticut 16830. This firm was founded in 1925 and became·a subsidiary of Time, Inc. in 1966. It publishes editions both of original prints and of color reproductions, plus a small number of black and white reproductions of work such as drawings.

Another large art reproduction publisher is: Donald Art Company, Inc., 90 South Ridge Street, Portchester, New York 10574. This firm issues reproductions on paper, canvas, hard board, plaques, and table mats.

Both firms are well geared to publicize, advertise, and distribute on a nationwide basis.

There are, of course, many other firms around the U.S. which you could locate through the yellow pages or your local art reproduction store. Try to learn something about their reliability before making a deal with them—from other artists who have had experience with them, from the Better Business Bureau, and the Chamber of Commerce. Be sure their contractual terms (in writing) conform to those outlined here.

When seeking consideration by a reproduction house, send color slides or other good reproductions. Don't expect immediate decision, for often their "juror" or "selection" staffs meet only once a month to make these decisions. Usually they do not purchase any originals, but rather the reproduction rights only. Each fee arrangement for an edition of reproductions is an individual matter.

6

COPYRIGHT, REGISTRY, ROYALTIES

The scandalous loss of copyright protection of works of art has long been a worry to art-specialist lawyers and a puzzling mystery to artists in this country.

Copyright Laws

The U.S. Copyright Law went into effect in 1909, was somewhat amended in 1912, then remained in its antiquated status quo for six decades before it began to be questioned and its inadequacies recognized. Its applications to works of art have been virtually unknown and not understood by artists, despite the fact that such laws actually go back to 1735 in England.

Carl Zigrosser, eminent curator, writer, and general authority on graphic work, wrote some fascinating historical material for the Print Council of America on art plagiarism, forgery, and fraudulent practices. It seems that it was only very gradually, during the Renaissance, that any protection for artists on these scores became an issue worthy even of consideration of any kind. Poor Dürer did not get very far in his efforts. In 1505 he traveled all the way from Germany to Venice (though perhaps this was not too formidable a trek, considering that Columbus had sailed the ocean blue 13 years earlier), where he vehemently protested the flagrant plagiarism of his prints. Raimondi, the guilty villain of the piece, was only ordered by the Venetian authorities not to use thereafter the Master's monogram on his spurious works.

In the next century Rubens was able to obtain only occasional special protection from the king for certain individual works. But by the 18th century, numerous British artists—including particularly Hogarth—were seriously suffering from piracy and were petitioning for protection. Parliament finally listened, passed the first general copyright law affecting artists in 1735, and *The Rake's Progress* series was published under the protection of this new Act of Parliament. Thus was established the basic principle of the artist's right in his own design, which spread to most countries. But all too often it exists more in theory than in practice.

New copyright revisions to apply to U.S. artists became the subject of bills offered in Congress in 1973, but their provisions still contained dangerous traps, according to artist-copyright-specialist, attorney Carl L. Zanger. He pointed out need for revisions of the revisions: to eliminate, for example, the concept that the moment a work of art might be shown any place where any public could see it, the work would be considered to be "in the public domain," and anyone could legally reproduce it for any purpose whatsoever, with no permission, no payment to the artist.

Meanwhile, artists were warned to cover themselves—*before* exhibiting anything anywhere—by affixing indelibly on each work of art: 1) signature, 2) year of execution of work, and 3) the symbol © (meaning copyright), thus establishing legally their protection against pirated reproduction. It is also helpful to label everything "All reproduction rights reserved." For additional proof of protection, artists can obtain copyright registration for $6.00 per work from the Register of Copyrights, Library of Congress, Washington, D.C. 20540.

At least awareness of the loopholes and lacunae in the law has developed. Perhaps by the time this is published, a reasonable, protective law applying to art will have been passed.

Registry

Meanwhile a system of "fingerprinting" works of art and registering them in a computer bank was invented in 1970 by two London constables named Chapman and Gerrard. Their purpose was more for deterring thefts and forgeries than for protecting living artists from plagiarism or illegal reproduction. They knew nothing about art, not even what they liked; but they knew fingerprinting and sleuthing. The coding system of these two young British bobbies won them

high praise all the way from Scotland Yard to the National Gallery of London.

Subsequent developments of the system are leading to quite possible uses in protecting any artist's works, and may eventually become the right arm of any effective copyright law—especially if mass use produces truly low-cost registration, which is already in a not expensive category. For the foolproof irrefutable identity of any original can now be filed in the computer bank of the International Art Registry, Ltd., a 107-nation organization.

Royalties

It is an old and oft-deplored story that all too frequently it is only the purchasers who receive the major benefits from their acquisitions of works by living artists.

In a number of European countries, artists now receive a percentage of any increased price in the sale of a work subsequent to its first sale. Thus the visual artist there has the same kind of "royalty" rights as composers and writers. West Germany joined these ranks in 1972 by revising copyright laws to require dealers and auctioneers— over their strenuous objections—to pay to the living artist 5% of such increases in resale prices. To prevent any arm-twisting pressure by an art dealer, their law does not permit the artist to waive this right. The artist is enabled to inspect the dealer's books, under the law.

In this country, a proposal was drawn up in 1971 by a volunteer lawyer, Robert Projansky of New York. (Artists: Please note how many dedicated souls you inspire to get out on the ramparts to fight for you!) His proposal provides that the artist must receive 15% of any price increase in resales of his work. The "Projansky Agreement" is not just a one-way street for artist benefits alone—which would be idealistically impractical; it requires the artist to provide the purchaser with a certified history and provenance of each work, thus guaranteeing its authenticity and accurate documentation, and thwarting fakes and frauds. The artist would also give advice in case any repairs were needed, and on appraisals of the work.

A copy of the Agreement would go with each work to each new owner, another copy to the artist at the time of each transfer. The collector would pay only if he sold the work at an increased price, when he would have received profitable income.

Although some exhibitions and sales are being conducted on this basis, so far they are few and far between. Unless we can get some

such measures written into our copyright laws—as in Europe—they are unlikely to become widespread or truly effective. Compared to composers and writers, the visual artist is the "red-headed step-child" of the arts. The writer, for example, has up to 56 years of copyright protection; income from upmarked resales; royalties for movie rights, for a play as long and as often as it may run, for paperback publication, for serialization.

Why not the artist?

Concerted Action

There are numerous artist organizations which work for these and other potential aids and reforms for the visual artist, and they are often effective. It is much harder for the studio artist, basically a loner, to participate in group action and pressure than for performing artists who work largely in groups and in public.

But you cannot just "let George do it" and sit back expecting organizations to take over for your interests. Effectiveness requires some participation, some awareness of issues and actions which affect your livelihood and welfare, your recognition and protection.

Unless you back your art organizations with at least ideological support, in writing or verbally, they are hard put to it to indicate that they really represent you and a good number of other artists when they undertake, for example, to testify for artists before Public Hearings in Washington and state capitals. Every fall, the politicians who are campaigning hold local meetings, with questions invited from the floor. Don't forget: You are voting constituents. Today, there are always bills pending, federal and state, which affect the arts. Ask the candidates how they stand on these issues. Even better, get other artists to back you up. If you are a part of a co-op gallery, an artists' union, a local art association, ask for a vote at a meeting to take a stand on upcoming art legislative issues. Then, in asking candidates or in communicating with legislators, you can say, "We represent X number of artist-voters."

7

GOVERNMENTAL AND NATIONAL AIDS TO ART

In recent years it has become more and more important for artists to be aware of various government arts organizations—federal, state and local—and the potentials they offer. More and more tax funds have been going into the encouragement and assistance of the "cultural resources of the nation," the term so frequently intoned like a religious chant—but if so acceptable, why not use it? The U.S. was late, compared to many other countries, to realize needs for government aids; we are still considerably behind some countries in the amounts per capita spent on the arts. But we are showing gradual improvement.

National Endowment for the Arts

At the top of the ladder is the National Endowment for the Arts (NEA), an "independent" agency of the Federal Government created in 1965, following backing first by President Kennedy, then by President Johnson. It is advised by the 26 members of the National Council on the Arts, who are appointed by the President, as is the Chairman of the NEA.

The Act which established this operation specifically prohibits any interference in the administration of policies or the determination of programs of any organizations or agencies involved in the arts. Thus the freedom and independence of artists' groups were guaranteed from the start against federal dictates. But in some peculiar "oversight" the same freedom was not guaranteed to individual

artists. Hopefully, this will be rectified, for all artists fear and resist censorship. So far there has been no indication of dictatorship or censorship from government agencies such as was all too apparent in the pre-War II days of WPA and US Treasury Section of Fine Arts Projects. If we encounter government controls now, they will doubtless be more subtle.

National Endowment for the Arts is now the major patron of the arts, far surpassing the sums contributed by any of the philanthropic foundations, which have been decreasing their aid to art. Whether this support for art will continue to increase depends to some extent on vigilance and awareness on the part of artists and their organizations. Every time the eternal cry arises to cut the budget, the arts are eyed suspiciously as "luxuries." Vigilance is also needed to try to obtain a fair share of arts allocations for visual artists; the much better organized performing artists consistently tend to get the lion's share.

Associated Councils of the Arts

The Associated Councils of the Arts (ACA), which acts as a catalyst, adviser and watchdog, is a national (not governmental) service organization. Although it receives some funds from NEA, it is backed by many private organizations and corporations and the U.S. public at large as "Advocate" members.

ACA distributes no funds. But it supplies information on how best to obtain them; gives art advice to states, regions, and communities; lobbies in Washington on matters affecting creative artists, such as censorship, individual rights, inequitable taxes, copyrights; aids in establishing community programs; gives professional information on art-related state legislation.

Art in Public Buildings

For years a program has been "on the books" for art in public buildings which receive any federal funds for their construction. Provisions require one-half of 1% up to a full 1% of total construction costs to be set aside for fine arts: murals, sculptures, stained glass, or other suitable forms of architectural art. Despite this long-time allocation, city, state and federal buildings have been constructed with no art, because the ruling does not *require* such art expenditure. Government appointed architects have been allowed to determine whether or not they want art in their buildings.

These funds, which derive from tax monies (like yours), could be of real assistance to many artists wherever proper use of such funds is enforced. The Office of Fine Arts of the General Services Administration, Washington, D.C. 20405, is in charge of federal building fine arts allotments and welcomes slides and résumés. For locally and regionally projected government buildings, your nearest Department of Public Works and its art or design division should supply the necessary procedural information.

A 1974 U.S. Conference of Mayors unanimously adopted a resolution urging: "That a percentage of the total cost of every municipal construction budget be set aside for the purchase or commission of works of art." This does not make it law. But whenever a city building is in the planning stages, it lends weight to artist efforts to assure implementation by City Hall.

State Councils on the Arts

Every state and territory now has its legislatively created arts council, for the expressed purpose of stimulating the creative and interpretive arts and outlets for them. Their support comes from the NEA, the individual state legislature's allocations, and matching grant funds from private sources.

Of course some State Councils are more effective in art activities than others. Much depends on local public interest and pressure. Artist organizations in numerous states have been able to increase greatly the benefits to their counties and communities by letter and telephone campaigns to their state legislators. In some states, councils are required to plan for decentralization of decision-making regarding smaller grants for community arts services, allotting the determinations to local bodies.

Museum Financing

Gradually government grants are reaching museums across the country, for staff, exhibitions, catalogs, and programs to extend to other community and regional institutions.

One of the most common artist complaints is summed up in a letter I received: "Our local museum pays little or no attention to work by local artists. How can we hope to get recognition when our own institution consistently turns its back on artists in its own region?"

Part of this problem is lack of funds. There is a striking contrast here with our neighbors, the Canadian museums, and their situation vis-à-vis government support. Canadian museums not only exhibit their artists, they pay them rental fees for showing in any publicly funded institution. Obviously we are sadly behind in our funding of museums. Perhaps we will catch up some day, if increased federal funds keep reaching our museums, or if more localities levy special museum taxes—such as those on hotels in California where it was decided that museums as tourist attractions are a boon to hotels.

Another part of the problem is the need for more creative, innovative programs in our museums. Towards this end there have been proposals and actions (notably by Artists' Equity) to require better representation of artists on museum boards, more say in policy making. However it may be achieved, probably no one questions that the museums should be genuine nationwide aids to living artists.

8

PRICING AND SELLING

Dealers will often ask you what price you want to place on your works. If you have sold only from your studio or in smaller metropolises, you may not know just how to do this. Obviously, the dealer is interested in asking as high a price as possible, for then his commission will bring him more revenue. It is also apparent that a dealer knows his own customers' pocketbooks better than anyone else. Since the interests of the dealer are the same as yours—to get as good a price as possible—your best bet may be to ask and take his advice on the matter. The dealer knows that he cannot overprice work by unknown artists; he realizes he can push up prices after successes; and he understands the range of his customers' buying habits. Some dealers have more wealthy clients than others; if pricing seems too low to you, it would be better to go to other dealers than to argue.

Pricing

Most of the artists I see are fairly modest, when they start out, as to what they think their work is worth on the market. One elderly painter wrote to me from Detroit: "What the artist should charge for his works is a hard question; well, I solved mine 40 years ago when my teacher and I set prices on worthwhile paintings at $15 for an 8″ x 10″ and a little more for the larger ones. Today my prices are $60 for an 8″ x 10″ to $250 for 16″ x 20″, and this price range has brought me a very satisfactory sales record, flowers accounting for most sales. Great wealth I did not amass, but it has been a very inter-

esting and rewarding experience, expanding around the U.S. and eventually many other places around the world."

I would like to mention that this letter came from a *male* artist, for some men tell me that it is their belief that only *females* who are otherwise supported can be modest in their demands.

Another query from a watercolorist whose work sells very well but at low prices, wonders if prices should be raised: "Isn't it better to charge less and try to get your work known first? Or am I placing too little value on my time, when a purchaser pays $60 to frame one of my watercolors? Now that bothers me completely!"

When work has a good market and is in increasing demand may be a good time to raise prices—but not too much all at once. It is perhaps advisable to keep in mind that if the increases put a stop to the sales, it could be demeaning to have to lower them again to recapture the market. One approach might be to step up prices gradually to test the absorption potential; another is for dealer and artist to set a price range within which the dealer can haggle, and thus see what the market will bear, while not losing sales.

If you can be objective about your work, try some "comparative shopping;" observe the price tags on somewhat similar works, and particularly on those which are wearing red stars. Sometimes a sympathetic dealer or a knowledgeable collector might be helpful in your evaluations, easier to make from the outside.

Occasionally I run into someone who has grandiose ideas. One man told me that he had never exhibited and never sold, but that he would take nothing less than $3,000 for one of his paintings. Would I please find him such a gallery? My reaction was that he would do better to hang his paintings on his own walls, instead, and to enjoy his expensive collection. Another artist, an unknown Florida painter, wrote: "I have about 200 primitive oil paintings, some in hand-made frames. Could you please give me the address of a gallery that might be interested in buying them? Have sold some of my paintings [for] $8500. . . ." One could only wonder, if true, why he would bother to try for a New York gallery.

There are indeed artists who feel that they are superior to all others and that they should be in a top price bracket even if still unknown. Perhaps their attitude is purely egotistical or paranoid. But it is also possible that they are exacerbated by the unreasonable demands of some purchasers who, even at low prices, want totally unreasonable assurances.

A purchaser of watercolors writes: "I don't understand what basis

is used for pricing," and he argues that an artist who produced a watercolor a day, five days a week for 11 months—a one-month vacation allowed—would have 240 paintings and, at $100 each, an income of $24,000 a year. (I wonder if he is a cost-accountant for mass-produced conveyor belt items.) "Yet few can make their living at fine art; most are pricing at more than $200, *not* selling, pricing people like me out of the market. The whole business appears crazy to me!"

The watercolor afficionado goes on to say that he wants "a masterpiece of its type, a work that can be lived with for years with a continuing realization of its excellence," plus hopefully a work "that would sell well at auction if I didn't like it after a time." There is never any intimation of his own potential inadequacies or limitations; the assumption is that the buyer must be supremely god-like. As if anyone could offer such guarantees on matters for which the responsibility rests in the collector's head! Such a purchaser would be the first to object if an artist or dealer tried to dictate what to buy; yet he obviously does not trust his own judgment and wants it to be "covered" by impossible promises.

Another inquiry came to me from some graduating students at a Massachusetts college: "We are considering a class gift for the school and would like any available information on statues. We would like something that could be placed as a centerpiece on the main quadrangle as a possible portrayal of the contemporary period. Our funds are limited to a $200 to $400 price range." One hopes that after their commencement, they commenced to learn a few practical facts—even if only about costs of materials, not to mention the livelihood of artists today.

Art as Investment

Novices in art buying are all too readily taken in by the get-rich-quick and you-can't-lose ballyhoo about art as an investment that has plagued the market for some years. A housewife called me from Queens to say she had seen a beautiful painting, all framed, of a head of a gypsy. It was selling for $75. "Do you think if I buy it, it will be worth ten times as much in two or three years?" She had been reading about top auction prices for big-name art and jumped to the conclusion that fabulous increases in value applied to all painting. Nor is this too surprising in view of the fact that much commercial promotion of art in recent years has used just such rare examples of

increases "far greater than any stock or bond on Wall Street" as a hard-sell approach: "You, too, may make a killing!"

"I'm mainly interested in buying art for profit and I'll spend quite a lot—what should I get?" asked another.

In reply to such queries, I usually try to convey the unglamorous and homely idea of buying art for pleasure; if it's worth X dollars to you to have on your wall, then buy it; if you start by buying something, anything you like, it may well open up a whole new, developing world for you—of pleasure. After a couple of years of art looking and shopping, your taste may change radically, you may then spurn your early purchases—but they will have served you well as introductions to a rich field.

Discounts

Museums and collectors: Artists and dealers alike must anticipate demands from certain quarters for discounts. All museums expect to buy at a discount, not only because they are non-profit educational institutions, but also because they know a museum acquisition enhances both the reputation and the market of an artist. In the past couple of decades, the generally accepted museum discount in New York has been reduced from 15% to 10%. Occasionally, however, galleries will give a little more when trying to get a new artist "put on the map."

Another category of discount buyer is the large collector who frequently buys in quantity. Just about every artist and dealer wants to be represented in certain well-known collections. A noted example is the collection of Joseph Hirschhorn, who for many years has extensively bought work by relatively unknown contemporary artists, often purchasing a score or more by the same artist. Many artists have been launched by these purchases and many have subsequently become well known. The collection—and a museum to house it—has now been given to the nation in Washington, D.C. For an artist's work to be part of the Hirschhorn Collection was for many years, even prior to establishment of the museum, as advantageous to his sales as to be represented in a museum. Consequently the same 10% discount was customarily applied.

Many big collectors agree to bequeath their art to a particular museum. The liberal tax allowances—even during the collector's lifetime—by the Internal Revenue Service have encouraged such procedures and are responsible for much privately owned work pass-

ing into the public domain. In this practice the United States compares very favorably with many other countries where, even when an art treasure is willed to a museum, the heirs must still pay inheritance tax on it. In many cases, therefore, the allowance of a discount to collectors is tantamount to a museum discount, for the works are pledged to wind up in museums.

An extremely unfortunate chapter in our tax legislation history was initiated by an unfair provision in the Tax Reform Act of 1969. Though primarily intended to curtail unreasonable tax deductions for politicians donating their papers to libraries, it inadvertently caught the artist in a "squeeze" and prevented him from deducting the market value of his work when donating to museums. While collectors and dealers were allowed such full value deduction, artists could deduct only the cost of materials used. This discriminatory law has not only hurt the artist, but has cut down enormously on the wealth of art in public insitutions. So much furor has been engendered by the inequitable measure that, hopefully, it will have been removed by the time this appears in print. The incalculable losses have already been perpetrated over much too long a period.

Other discounts: Most dealers also give a 10% discount to educational institutions other than museums, such as universities, colleges, libraries. Many give preferential prices on purchases by other galleries, and as a commission to architects and decorators buying for their clients. Not infrequently, an artist or student purchaser is allowed a discount; I know one dealer who will take off 10% for an eager purchaser if he is poor. Though I am puzzled about how the "means test" (or gauge of pocketbook) is applied, I do know that I have benefitted by this kindly attitude. Discounts may also be offered by a dealer when he is selling off inventory.

Sales from the Studio

Lots of people prefer to purchase directly from an artist's studio, rather than from his gallery. Often this preference simply stems from a desire to see and talk with a real live artist, and to get in behind the scenes; it makes prestigious cocktail conversation about their purchase. Creative artists often fill many people with awe. Artists respond to this adulation in reactions that range from total rejection of such invasions and interruptions, to long-suffering toleration, to a pleased and friendly welcome.

Another big reason why purchasers prefer to visit an artist's studio rather than go to his gallery is to try to persuade the artist to sell without the dealer's commission, promising that they won't tell. This tactic, of course, violates all artist-dealer commitments. Nevertheless, a cagey buyer figures it will be easier to twist the arm of an unbusinesslike artist than to bicker with his professional dealer.

At the Art Information Center, I often receive calls asking for an artist's address. Unless the artist has no gallery affiliation, I give out only the name and address of his dealer. Compilations such as *Who's Who in American Art* and the *International Directory of Arts* do publish artists' addresses, but many purchasers either don't seem to know these sources or don't want to go to look them up in the library. And I never suggest these reference works. To mention the fact here is, I hope, "safe" because this book, directed to artists and dealers, is not likely to be read by collectors. The by-passing procedure by a collector is not only unfair to the dealer, but is also a burden, an embarrassment, and a nuisance to the artist.

Dealers themselves frequently make appointments with their artists for purchasers to visit studios, with the understanding, of course, that no price dickering will ensue. For practical reasons of space, the dealer may have only a few of the artist's works on hand; the purchaser may wish to see more before making a selection. If the artist is affiliated with a gallery, this is the acceptable way in which sales are made from his studio with integrity.

Outright Purchases

Very few "art dealers" buy work outright from living artists. Some occasionally buy work by artists in their own roster for their personal collections. A few make purchases from their artists in cases of need. A few buy on a monthly payment basis as a kind of advance to an artist. In such a case—which is rare—if the work is later sold, the dealer takes half the sales price and deducts from the artist's 50% whatever payments have already been made to him.

A number of the dealers who work with the interior design and decorator trade do often buy outright. They are usually located near the centers of such trade; they are catering to decorators, who in turn are catering to their clients. The decorators must get their commission if they produce clients; the dealer must get his commission if he sells your work. With an extra "middleman," it becomes more difficult for the dealer to work with the artist on the usual commission

basis; he will try to buy outright for as little as possible, sell for as much as possible, and hope his judgment and sales pitch are good enough to assure his profits.

In the low-priced market, there are "picture" dealers who buy outright for quick, inexpensive turnover. Perhaps the largest and most widespread is Arts International, Ltd., with headquarters at 59 Walton Street, Chicago, galleries in numerous cities of the United States, and offices in five European capitals. Their sales prices range from $15 to $150, including their commission, so the artist is lucky if he gets half these amounts. For prolific producers this arrangement can still mean income, as it doubtless also does to foreign artists to whom dollars may be worth more than in the United States. Numerous frame shops also buy paintings, drawings, and prints to display and sell with their frames, often with a sign: "This picture with any frame in the window—$75."

Naturally, such purchasers will try to bargain with the artist. They are probably much more shrewd as businessmen than most artists, who verily are not precisely noted for astuteness in transactions involving their work even when being sold down the river. But you must realize these dealers are running some risk when they put cash in your jeans before they know whether or not they have sales.

Installment Buying

For many years galleries have sold on the installment plan, and virtually all galleries continue to do so. Losses from this arrangement have proved to be virtually nil.

I remember making a fairly comprehensive telephone check among New York dealers on this subject when I was Publicity Director of the Museum of Modern Art in New York. The Museum was then thinking of establishing its art lending library—a potential form of installment purchase, for the borrower can subtract rental fees from purchase price if he later decides to buy. Not one of the dealers I called was unwilling to sell "on time"; and not one had ever lost on such sales, although they sometimes had to wait as long as two years for final payment—even, occasionally, when the total sum was only $600 to $800.

Apparently, people who want to buy contemporary art are not swindlers. Possibly the individual and personal experience of buying work by a living artist is more exacting than dealing with a big impersonal corporation. Six psychologists would probably come up

with six other theories. Whatever the reason, it is to be hoped that nothing—especially this report—will encourage swindlers to move in and change this happy situation.

Many dealers stipulate a time limit on long-term purchases, from six months to two years; but some simply state "open" or "extended." I once arranged to buy a $125 lithograph from a gallery which required no down payment whatsoever. But I did pay a first installment of $50 and asked the dealer to hold the print until I could accumulate the rest of the funds. He was actually angry. "I don't care if you don't pay anything now," he said, "but please you must take it home because I might forget and sell it again. And anyway I don't want it cluttering up my limited storage space."

Before making the arrangement, dealers selling on time are apt to consult with the artist to ascertain whether he will accept delayed payments; most artists do. In some cases, the dealer agrees to pay the artist in full at the time of the first installment and himself to wait to be reimbursed from the subsequent sums.

Unfortunately I must record one exception to the above rosy report; it is one which brings up a curious and rather surprising legal aspect. A dealer sold an artist's painting on credit, but was unable to collect either payment or the painting from the purchaser. Artists' Equity took the painter's case to the Attorney General's office, only to find that it was the artist who had to sustain the loss if the dealer could get neither the money nor the painting. Legally, the dealer, who did not get his commission, had already sustained his share of the loss. The artist could sue the dealer for negligence in checking his client's credit; but if he did, he would probably spend a lot more for legal costs than he originally lost in the price of his painting. One can only hope that this case is the exception which proves the rule.

Returns

Purchasers who want to return works of art for cash may not be successful in their efforts, for once the dealer has paid the artist, bookkeeping becomes complicated; and more likely than not the money has been spent. But dealers do make allowances for purchasers who go home with a painting or sculpture and immediately discover that it doesn't "live with" according to their expectations: art can look very different in different surroundings. Some dealers will return cash if the work is brought back within a month. More often, credit is extended or an exchange is arranged.

A purchaser will probably encounter no difficulty if he wants to exchange the unwanted piece for another, more expensive work by the same artist, and if he is willing to pay the difference. This practice is not infrequent, both for private collectors and for museums. The New York Museum of Modern Art, for example, buys many works by living artists on the understanding that they may later be exchanged for more recent works, often at additional cost; thus it can attempt to remain a museum of "modern" art. But never does the Museum turn in works by living artists if this means that these artists will no longer be represented in the Museum collection. Once an artist has achieved the right to say that his work is owned by the Museum, it would be manifestly unfair and harmful to his professional standing to deprive him later of that right.

9

PUBLICITY

There are some 400 newspapers in the U.S. which cover art events. A list of these papers, with the names of their art critics, can be found in the appendix to the American Federation of Art's *American Art Directory*, a reference book that is revised and reissued every three years; this directory is not hard to find in libraries and museums. Newspapers which have no art critics often cover art events and shows as features, perhaps on the women's pages or in amusements and leisure sections.

Press: Advertisements and Listings

In New York it is widely agreed that the most valuable advertising medium is the Sunday *New York Times*. The Sunday edition has much broader distribution in the nation than does the daily; and dealers, even in other parts of the country, have found that its ads may well draw more attention and results than other publications. The *Times* also has a Saturday page of art reviews and, Saturday being the biggest gallery-going day, New Yorkers frequently use this page as a guide for their visits. Hence, for local purposes, many dealers also advertise on Saturday. To encourage this practice, the *Times* offers a "tie-in" discount price if the same advertisement is placed on both Saturday and Sunday, either on the two consecutive days or six days apart.

The major monthly art magazines, *The Art Gallery, Art News* and

Arts, have national distribution and national listings and reviews, although their sale are heaviest in the New York area. Shows and the publicity for them must be planned well in advance, for ads must be sent to these monthly publications about four weeks before their publication dates.

The opinions of dealers vary considerably regarding the value of advertising in art magazines. Many galleries have annual contracts to advertise in every issue at a discount rate; some don't use the monthlies at all; one well-known dealer places small ads regularly—not, he says, because he thinks they bring him any results, but because we have so few art publications in this country that he thinks they should be supported.

American Artist has the largest circulation in the United States among monthly art magazines, but this publication is designed to be technically and factually informative to artists. It does not review gallery shows, therefore, ads for exhibitions would not reach the right audience. *Art International* is published in English in Switzerland, but covers much United States art news and has a good percentage of its circulation here; it is used as an advertising medium by numerous dealers, particularly in New York.

The big weeklies like *Time, Newsweek, Cue,* and *The New Yorker,* are not frequently used for gallery ads, first because they are just too expensive, and then because their readership is not primarily interested in contemporary fine arts. Moreover, there is no assurance that an art ad will appear on the art page; it may just get "lost" somewhere in an irrelevant section.

Many publications list current exhibitions and announce shows about to open. This information is considered editorial copy and therefore costs nothing. Naturally, editors may select what they will list; there is no assurance of complete listing of all galleries.

But in all too many instances a gallery listing is omitted only because the dealer did not get his information to the publication before the deadline. In general, listing information must reach the publication earlier than advertising copy. This is a useful form of free publicity and is used as a guide by many readers. In addition to the art magazines, listings appear in such widely circulated publications as *Cue, The New Yorker* and the New York Sunday *Times.* The latter lists interesting shows, particularly in summer, from Maine to Washington, D.C. Many newspapers across the country, especially those with art critics, list local and regional exhibitions.

Gallery Guides

In a number of cities such as New York, Los Angeles, and Louisville, where there are numerous galleries, a monthly booklet is published, listing galleries, giving their addresses and phone numbers, announcing the shows they will have during the month ahead, and specifying the days and hours of visiting. Usually the galleries must pay for these listings. In return, they receive a number of free copies to hand out, or to sell, to their visitors.

The most comprehensive of the guides is the insert published along with *The Art Gallery* monthly. It solicits paid listings from all over the U.S., and the magazine covers art activities in many parts of the country. But the listings are never complete, because some galleries do not choose to pay the charges. There is no complete listing.

These booklets also carry advertisements, as well as reproductions and some editorial copy. A gallery which pays for a listing should send along with its information copy a couple of photographs of work by its exhibiting artists. A reproduction may well be used editorially if it is on hand when layouts are being made for these pocket-sized booklets. If the gallery decides to take not only a listing, but also an advertisement, the publishers are practically certain to use a reproduction in the editorial part of the magazine.

Press Releases

A simple, factual, directly written press release can often be helpful to art reviewers and reporters, and hence helpful to the artist in gaining their attention. The kinds to avoid are the flowery, emotional, exaggerated, or introspectively philosophical verbosities that too often emanate from the inexperienced or the egotistical. Press people, who have neither the time nor the patience for such flights of fancy, tend to file them in the waste basket.

The old newsman's 4-W rule, that who, what, where, and when must appear in the first sentence, is a good one. With all the releases that cross my desk, I become irritated when I have to search through numerous paragraphs to discover the opening date of a show, or to find what, in essence, is to be exhibited. Although it should be succinct, it does no harm in the first paragraph to repeat the name and address of the exhibiting gallery, even though these probably also appear in the letterhead above. The reader's eye often goes directly to the body of the text, failing to encompass the larger type at the

top. This observation reminds me of the well-known map publishing firm which issued a huge map of the United States, for which dozens of girls checked the spelling of every little village. When the map came from the press, UNTIED STATES was printed in huge letters across the whole thing: the type was so large that no one saw it.

Using the straight facts, try to write a paragraph or two that describe the art to be shown in a manner which will help to visualize it. I have heard an art magazine editor wisely explain to a new reviewer the following approach: think and write as if the reader would never actually see the works of art, so that the words convey the image. Some artists are themselves the ones best able to describe their work; quotations from their statements may well be pertinent. The press likes to use direct quotations because quotes give the impression of having come from the "horse's mouth" (and they fill space without effort or thought).

In a press release you are addressing people who presumably have some knowledge of the field and who can thus comprehend art references. Don't hesitate to make comparisons to other artists and their work if these references will help in visualization. There is nothing pejorative about implying that work stems from, say, Matisse or Shahn or Pollock. All serious artists have derived to some extent from their predecessors.

If the exhibiting artist has already been discussed in press notices and reviews, include some quotations from these clippings, advantageously selecting the best, most favorable comments on his work.

The last paragraph of a press release is a good place to give a brief sketch of the artist's professional background: where and with whom he studied; where and when he has exhibited; what collections own examples of his work—especially public collections, but also private ones if they are of importance. Biographical details other than those relating to art background are usually superfluous, unless they relate in some way to the artist's point of view as expressed in his work, or are needed to explain a gap in the continuity of his art production. The biography is sometimes set up in single-spaced copy while the rest of the release is double spaced. This tends to set it apart visually, an aid to the reader pressed for time. It also on occasion saves expenditure, for the single spacing may eliminate the need to run onto an additional page at added cost in mimeographing or offsetting.

If there really is a lot to say and it is expressed in an attention-holding way, there is no harm in a release that is three or four pages

long. But if the material can be stated adequately and interestingly in one page, don't drag it out with padding.

Since reproductions are often important to the press, it is advisable to state at the end of the release: PHOTOGRAPHS AVAILABLE, with the telephone number of the gallery where they may be obtained.

It pays to proofread stencils or copy prepared by a printer for mimeographing or offset before it is printed. Typographical errors are generally all too common; when a typist is confronted with technical terms or words totally new and unfamiliar to him, there is no telling how he will mutilate them. *Collage* is almost certain to come out as *college*, and it would seem that most typists are congenitally unable to spell words like *acrylic* and *asymmetric*, even when they are reading accurate copy. This kind of error gives a sloppy, non-professional mien to your show and may influence the reader to think that the whole affair is pretty amateurish.

It is occasionally possible to find a publicity agent specializing in the field of art who knows how to write a good press release and who also maintains an up-to-date press mailing list. But this is rare—and it means an additional cost. Most releases are written by the dealer, and sometimes by the artist, if he has a flair for writing. Results are apt to be more sincere, more accurate, and more effective than those achieved by a hired P.R. hack who knows little or nothing of art and who uses the same sensational approach for everything, whether the subject is art, soap, or racing cars. Most dealers maintain their own mailing lists of press, museum personnel, and customers.

How to Use a Press Release

Editors of the art monthlies, art reviewers for weeklies, and art critics of local daily papers should receive copies of the press release. It is also advantageous to reach editors and writers who work for general periodicals which only occasionally include features on art subjects. You never know when the material you send them may fit in with the theme of some special article they are contemplating. Once you have already ordered the stencils or plates for printing the release, it costs only the small amount for the additional paper to have more copies run off to mail to such feature writers and editors.

If you can write covering letters pointing out the particular feature possibilities of your show, so much the better. Many women artists have thus received coverage on women's pages and in women's magazines. Works of art with a particular slant or theme—whether

political, ethnic, technological, or musical—have aroused interest from writers on related subjects.

Curators and directors of local museums which show contemporary art should also be on the mailing list, and some dealers like to mail the release to their customers. Artists often send copies to previous purchasers, perhaps along with an invitation to the preview on which is written something banal but personal, like "Hope you can come." Architects, decorators, and designers may be in a position to influence their clients towards purchasing and commissioning contemporary art. As this trend has grown, more and more dealers and artists have built up their mailing lists to include such professionals, who have become important intermediaries. Indeed, in many areas, certain dealers cater especially to this trade, which by itself can supply them with good business.

Many dealers order fifty to a hundred extra copies of the press release to hand out in the gallery, not only to visiting press, but to anyone who shows an interest in the artist's work and wishes information about him. Moreover, they need a few copies to file for future show reference.

Mailing houses—often combined with mimeograph and offset operations—are widely used as expeditors for releases, invitations, brochures, and catalogs (though a good many small galleries address their own mailings by hand). The mailing houses generally operate by machine, putting the list on addressograph plates which are run off automatically onto the envelopes. They can easily separate the lists under different headings, such as: press, museums, architects, customers, in case the dealer wishes to use different sections of his list for different shows. It is important to notify the mailers of any changes in names and addresses and to keep the list up to date. Mailing houses will also address by hand from a special list used so seldom that it is not worth putting onto plates.

Along with the release, it is helpful to send a couple of photographs of the artist's work to a few hand-picked publications such as the art monthlies and the dailies which use art reproductions. Such photographs should have a glossy finish so they can be reproduced; standard sizes are usually 5″ x 7″ or 8″ x 10″. If feasible, send one horizontal picture and one vertical, for the publication then has a better chance to fit one or the other into the layout (the space may permit either a one-column or a two-column cut).

Give the critics as much convincing material as possible, but don't badger them with visits and phone calls. Some artists and dealers

have made themselves the *bêtes-noires* of local critics by constantly pestering them, with the inevitable result that the critics want to stay as far away as possible.

Personal Publicity

Sometimes artists who are looking for gallery representation ask me how they can get personal publicity; if they could obtain press coverage, they reason, they would then find a gallery. Actually this is a cart-before-horse approach. To send out a release or other promotion piece without any newspeg such as a forthcoming exhibition, is apt to be a complete waste of time and money. Once in a great while an artist can attract press notice by falling through a window, or by painting while standing on his head. But most of the time the press is too busy to notice; moreover, such feats are unlikely to induce purchases by museums or serious collectors or, in the long run, to build up a professional reputation for the artist.

If, however, there is legitimate, bona fide press material regarding an artist, by all means use it. A prize, fellowship, or grant won, a sale to a locally important collector, a donation or sale to a museum or other institution can make genuine news. Some artists can also make good copy for personality profiles. This kind of publicity can help to promote acceptance, to obtain new customers, to increase prices. Send copies of any such news piece to other media, to your collectors and prospective buyers, in order to engender greater interest in your current output.

One useful way to build up your art background and potential publicity is to offer gifts of drawings and prints to local museums. Naturally the curators will not accept them, even as gifts, unless they find the art worthy, but they are more apt to acquiesce if they don't have to strain their limited budgets. If the donations are accepted, you can then legitimately state that your work is "in the collection" of this and that museum. No need to mention that the works are graphics, which are easier to give away and less depleting of your major works which, of course, you would prefer to retain for selling.

If you can get listed in *Who's Who in American Art* and/or any of the Marquis *Who's Who* publications, this can indeed be helpful personal publicity. The inclusions in these volumes are screened on the basis of merit; as most people know, the listings cannot be bought, and there is no requirement to purchase the book in order to be in-

cluded. What often is not realized is the fact that to be listed in any of the numerous other imitative compilations which do require a fee or a purchase, means nothing. They are simply a way to take your hard-earned cash.

Some publications in this latter category state that they screen résumés, but anyone who sends along the check gets in. Some try to sound prestigious by saying that they are members of the American Federation of Arts (for which *Who's Who in American Art* is published) or of the American Association of Museums. Anyone can be a member of these organizations by simply paying the dues. Some tell you the Library of Congress Card number of their publication. Virtually any book published in the U.S. is assigned a card number on deposit of two copies with the Library. Not all such operations are American; some of the solicitation comes from abroad in an endeavor to glean American money.

A related maneuver is the proposal from some self-styled College, which no one ever heard of, to give you an honorary doctoral degree. Buried deep in the descriptive literature is a statement regarding the minimum "contribution" required, which through some sort of tax loophole may even be tax deductible.

In sum, the simple rule of thumb is: Don't pay for "honors." This, of course, does not apply to membership in professional organizations.

If you feel that you have amassed enough background in art to warrant inclusion in *Who's Who in American Art*, write for an application form to: Jacques Cattell Press, Box 25001, Tempe, Arizona 85282. Decision will be made on the basis of the information you supply on the form. If you do not make it the first time, keep building up your record and apply again in two or three years. The publication is compiled and issued every three of four years.

Brochures, Catalogs, Invitations

Announcements of exhibitions range all the way from a simple postcard to a book full of color reproductions, with many imaginative variations and eye-catchers among them. A good deal of ingenuity and inventiveness go into some announcements, frequently designed by the artists in keeping with their work. New materials, new printing techniques, and new formats are constantly popping up among these mailing pieces which, when they are truly imaginative, achieve the aim of being noticed and posted—sometimes even be-

coming collectors' items. The most expensive product is by no means necessarily the most appealing, effective, or attention-getting.

Brochures usually include the artist's art background in outline form, often digested from the press release; a checklist of work to be exhibited, with title or number, medium, and size of each (height should precede width, according to standard museum practice); and perhaps a favorable quotation or two from an art writer or a previous press notice. However, if the mailing piece is a poster or similar format that limits the space for text, a mimeographed checklist and biography may be folded in with it or handed out at the show.

Galleries which publish catalogs with color reproductions often arrange to have the four-color plates made by engraving firms abroad. Not only is the craftsmanship likely to be of high caliber, but it may be considerably cheaper than similar work done in the United States. In recent years, however, some American firms have been developing towards quality and prices more comparable with those in Europe. If color plates are made, a dealer may subsequently be able to use them for additional publicity by offering them, or electros made from them, to art publications. Such an arrangement is sometimes worked out in advance between a dealer and an editor so that size of color reproduction and time of delivery of plates will suit the needs of both. Obviously, this kind of publicity takes careful advance planning, and is not achieved by the last-minute rush into print which is all too typical of many publicity efforts.

Some dealers with a long-range view put out a periodic bulletin about their artists: where they have exhibited, sold, or been commissioned, and other facts relevant to their recent biographies. These bulletins are not primarily produced to obtain immediate press notice, but the information they contain is likely to go into the morgues of various publications, to be drawn upon at a later, more appropriate time. Bulletins are sent not only to the press, but also to collectors of the artists' works, to keep them and their interest in the artists informed and ever alert.

There are various theories about when to mail announcements and brochures. One of the most common is that they should be posted about ten days before the opening: the recipient should then have sufficient notice to attend, but not enough time to forget about it; and the frequent Post Office delays would still not make delivery too late. Another practice is to send notices only one or two days

ahead, which I suspect is more a practice than a policy, based on insufficient advance planning rather than on any tenable theory. Many of these arrive after the opening.

Radio and Television

It is pretty difficult to arouse interest in gallery showings from the big commercial radio and television stations. Although they must carry some cultural-educational material, they are more inclined to cover big museum shows to fulfill this requirement. Many stations do, however, give listings of forthcoming events in the arts; and it is indeed worthwhile to see that these programmers receive notices of gallery exhibitions.

Educational television, now so much on the rise, does offer good potentialities. These channels should certainly be on regular mailing lists; they should also receive photographs, preferably 8″ x 10″, and dull finished (not glossy) so they do not reflect the high-powered lights. Because of the usual shape of the television screen, horizontal pictures come over better and larger than vertical. These stations are much more likely to give illustrated spot announcements of forthcoming shows than are the commercial channels.

The educational channels, like the commercial ones, are more inclined to emphasize in feature coverage the activities of museums. However, the museums themselves are always looking for interesting material to supply. A good artist who is also an able speaker in interview and discussion situations or who is adept at demonstrations is a boon to this kind of program and should be brought to the attention not only of the educational channel, but also of the museum's publicity department. Also in constant demand are good ideas for television shows that have action, dialogue, and controversy, accompanied by telegenic original material. If the station does not have the funds to send out cameras and crews for shooting on location, then it becomes important to select material which can be transported to the studio.

An artist's chances of obtaining television time are greater if his work can be tied in with a public institution. The channel likes this stamp of authority, which removes from its personnel the onus of making selections in a field they may not know well, and of seeming

to "play favorites" among artists and their galleries. Of course, the museum is concerned about its own reputation for good judgment; it is not likely, then, to sponsor the television appearance of artists whose work it deems unworthy of hanging on its walls. In addition, you should consider—before proposing shows to museum publicity directors—that it takes a surprisingly large amount of material to make a decent television presentation. One good "idea" can sometimes be completely exhausted in fifty seconds. A lot of visual and verbal material, and a great deal of thought, must be stacked into even a 10-minute program.

Speeches, Demonstrations, Happenings

Publicity build-up for an artist is often achieved not only by radio and television appearances, but also through lectures and demonstrations at art schools, clubs, and other organizations. The artist who proves himself able and interesting in making public appearances of this kind is likely to be offered opportunities to become better known. Museums which operate art schools are frequently happy to schedule such events for utilizing the talents of local artists for their students, adult or juvenile. Programs of this nature are also organized for museum members. State and regional art associations (listed with the names of their officers in the *American Art Directory*), and the many art—literary—culture clubs which have latched onto modern art as "in" are also susceptible. Most of these organizations pay artists at least a small honorarium for such services.

An old technique used for attracting notice is the stunt that shocks—a tactic probably stemming from the Dadaists of the 1917–1920 period. The "events" and "happenings" of the 1960s quite frankly were called "neo-Dada," and in some instances they achieved as much attention as did the toilet seat the Dadaists once hung as a work of art.

Many of the stunts have come and gone so fast, only fleetingly making their impact, that it is unlikely they achieved any real place in history: whether they involved defecations at New York's Judson Church Gallery, nudist activities in the East Village, wrapping-up of entire buildings in various parts of the U.S., or stretching a curtain across a Colorado canyon. Like "streaking," the mere mention usually just produces a quirky smile and the "Yes I remember that, wasn't it amusing?" response indicating the impermanent. Some

stunts are based on genuine "reform" motives—as was the Dada movement in the opinion of many art historians. More often they are devised purely as quick attention-getters, resulting in an amused raised eyebrow as response to their purposeless sensationalism—which may downgrade the participating artists' reputations.

10

CO-OPERATIVE

There is a constant search by artists for alternatives to the gallery system, for there are so many more artists than dealers to show them, and there may be many frustrations in the artist's attempts to obtain adequate representation. One alternative which is becoming more and more popular is the co-operative gallery.

Beginnings

Co-ops sprouted in New York City after World War II, often with artist members, assisted by relatives, doing most of the installation work and manning the gallery on a rotating basis. A number have been sufficiently successful to move into better quarters and hire manager-directors instead of artists "baby-sitting" the galleries themselves. Problems of operating a gallery in New York, with its fierce competition, high rents, and artists scattered geographically, are greater than just about anywhere else on the globe. So the fact that some co-ops have made the grade there should indeed be encouraging for their development elsewhere.

Laying the Groundwork

In forming a nucleus of artists to set up a co-op, it is helpful to obtain work in various styles and mediums, to appeal to various art tastes and pocketbooks. It is also advantageous to keep in mind that you will need people who know about handling money and accounts,

who can write press releases, who will do physical labor. These might be artist members or reliable outside well-wishers whose assistance can be counted on when needed. At the start you may have only a half-dozen solid and dedicated members to lay groundwork and establish procedures.

Once you have a nucleus of artists, start worrying about money at least six months before opening the gallery. If possible, get a backer—perhaps from industry: paint suppliers or framers, or possibly a firm like a department store that may like prestige publicity.

Elect officers. Most important is the treasurer, who needs to realize that whatever monthly dues or initiation fees you establish should be far more than just to cover normal operating costs. For, as one co-op president puts it, "There are many hidden woes ready to crop up in the life of a gallery, such as worn floors, broken pipes, insufficient wiring, inadequate storage, etc., etc." The nucleus is going to want to expand with new members before opening the gallery. But before anyone joins, it should be made clear that he or she is expected to give time, labor, and money to the gallery—on time, for dues in arrears will not pay the rent, and offers of help next week will not get this week's show on the walls. It is important to have enough money on hand so that you are not pushed into accepting members just for the additional cash.

Besides a president and vice-president, you will need a secretary who keeps minutes of your meetings and who might also double as head of a publicity committee, if you can get someone who has facility in writing. Also someone in charge of installations and someone to be responsible for getting the printing done on time and accurately and inexpensively.

Enlist the interest of the community: emphasize your educational functions for the area; get public opinion behind the venture. Perhaps a local politician will make a public statement of approval; perhaps stores and businesses will agree to mention your shows in their ads as prestige publicity for themselves. The more local acceptance and recognition you achieve, the more likely you are to gain attention and make sales. You are also more likely to obtain donations and backing—not only in funds, but perhaps in space and services supplied.

If a department store has sufficient suitable space, it might turn it over to you, either free or at a low rent, with a view to drawing in additional populace. If you offer credit lines, some equipment or skilled services may be donated or considerably reduced. It is easy to

put on a brochure or checklist, "Printed as a public service by . . ." or a note on the gallery wall, "Lighting kindly donated by. . . ." You can promise donors that you will give them grateful acknowledgment in a gallery ad in the local paper.

To find likely people for these potential aids, ask the advice of some business or other community leaders. Then you can go to those they suggest with their names as introduction and reference.

Space Considerations

Locate adequate space for the gallery. You need two display rooms or sections: one for one-man shows, one to house a small sampling of each member's work always to be on hand and easily available for customers. You also need storage space and bins. For storage and for backroom samplings, many galleries find useful the sliding panels of heavy crisscross wire, on both sides of which you can hang paintings and slide out at will. This is a space saver, not necessary if you have plenty of room. Sculpture is not this easy to store, but it can often be housed on shelves built to accommodate various heights.

Utilities

By all means check the wiring and lighting potentials. You need a lot of lighting, so the "load" potential of the wiring is important. I went to one opening preview where overloading blew out everything; assembled guests had to grope grumpily down black stairs— certainly not disposing them towards purchases. Although artist members can do a great deal of the renovation work, this is an area where skilled labor may well be needed.

Lighting needs to be flexible to suit different exhibitions. Simple "spots" that rotate and have magnifying lenses are commonly available and frequently used by galleries. If liberally strung along the ceiling, they lend themselves to various adjustments so that each different show may have its proper illumination. But avoid any lighting that has a tint or color, for this will distort painting colors.

In addition to essential heating and plumbing, certain "housekeeping" details can be useful. A sink, a hot plate, a refrigerator add much to the comfort of anyone spending the day tending the gallery and are useful in serving refreshments at openings and to purchasers as a gracious amenity.

Seeking New Members

Once you have determined your gallery quarters, you may well start looking for some additional artist members, the nucleus group deciding by vote on the merits of each prospective member's qualifications and work. You should probably never have more than about 25 total, and there is no necessity to collect them at once, for it is always possible to add later. The number is predicated on the fairly usual procedure of giving each artist a one-man show every two years. It has been the experience of many galleries that exhibitions need to run close to three weeks in order to "catch on." Thus, if each show runs 18 or 19 days (to allow time between to set up the next show), and if the art season is considered to be from mid-September to mid-June, there are only 26 exhibition periods in two years. One of these you will probably want to dedicate each year to a pre-Christmas group show of works in lower-priced categories as potential gifts.

The number may, however, be varied according to the size of the gallery space. If you do not have enough backroom space to house, say, three works by each member, perhaps you will want fewer members. If space permits two one-man shows at a time plus the needed additional storage, you may be able to take in more artists.

Establishing Fees and Commissions

When you have decided how many artists you want to accommodate, you will need to determine how much each member is to pay in monthly dues and/or initiation fees. These are based on your projected costs plus that all-essential extra cushion. You will also have to establish what commission the gallery will charge on sales. In New York, a number of co-ops charge $25–$30 in fees per month and take a commission of 20%–25%, requiring the artist to pay for his own one-man show publicity (brochure printing and mailing, ads, preview costs). Others require a contract at perhaps $800/year, take only 5% commission and pay for all publicity. In some instances (unlike private dealers), co-ops take no commissions on work sold by the artist. Co-op commissions are always geared lower than those of private dealers.

These New York experiences may serve to some extent as guidelines. But you will need to orient your scale to local conditions. In New York the private dealer's normal commission is 40%, except

that it is now usually 50% on graphic work; elsewhere it may be 33⅓%. Rents are probably higher in New York, and the figures cited above are from co-ops that hire manager-directors.

With the newly elected members you will have additional help for the committees; they will probably volunteer for committees on the basis of their interests and abilities and whom they know in town who could be useful. And there will be more hands to help on pitching into fixing up the space.

Sprucing Up

The paint on the walls needs to be a noncompetitive background, like white or sand or pale terra cotta. Pegboard or composition board of a rough-textured type that will not show nail holes is often used to make each new installation easier. Equipment must of course include telephone, desk, file cabinet, typewriter, a few chairs, and perhaps a bench, ashtrays, and a vase to house flowers sent to openings. Like the hot plate and refrigerator, much of this equipment can probably be rounded up from friends' castoffs or from second-hand thrift sales. You can probably get away with no liability insurance, but be sure to reduce hazards like rough floors that trip people, projecting shelves that might hit heads, or dark stairs. For openings with wine, punch, or liquor, the "best" galleries are using simple, clear plastic glasses, which are inexpensive. Unless you have a big desk from which to serve and on which to put out some pretzels and potato chips, you will need a table or a 4' x 8' sheet of plyboard set on legs.

Pricing

Many artists are puzzled as to how to price their work. If you have sold from your studio, the price you charged may have been on the low side, especially to a friend. But studio sales entail no gallery commission or overhead costs. When you sell more professionally from a gallery, the privileged friends should easily understand why prices may now be higher. But don't price yourselves out of the market. It is better to start at a lower rate and then, after sales and successes, increase prices, rather than to have to decrease them due to poor sales.

Big collectors who pay big prices tend to go to major art centers for such purchases, but they and others will often buy locally in the

lower price brackets. Many galleries in smaller towns have found it wise to show work at prices not over $500 to $600. If possible, check with other galleries in similar localities and do some "comparative shopping."

Some galleries believe in the "direct approach" of putting the price of each item right on its wall label. Others type up a price list (usually covered wih cellophane for protection and marked "For Gallery use only," so it won't be carried away) for anyone to consult at the desk. In any case, prices should be visible and easily available, for many people shrink from asking prices.

Insurance

You may wish to carry insurance just on the gallery itself and your investment in it, leaving the insurance of the art up to individual artists. Dealer galleries which do insure art usually cover only up to a maximum of about 40% of what the artist would receive from sales, and that only for work while it is actually on the premises. Hence, artists who want their work covered while in studio, in transit, or on loan to friends need to carry additional inland marine policies. In a co-op, where costs are shared anyway, art insurance can just as well be left up to each individual. Indeed, there are certain conditions under which it is impossible to obtain any insurance, such as a gallery above a restaurant: insurers fear fire from commercial kitchens and will take no risks. In major art centers like New York and Chicago, art insurance has become very difficult to obtain because of the increase in art thefts.

The possibilities of theft can be diminished by wiring down small, easily snatched sculptures or other works. Of course, proper locks on windows and doors are needed as well as constant, watchful guarding when the gallery is open.

Publicity

Printing and publicity should be considered prior to the opening of the gallery. Some kind of catalog is needed for each show. This may be anything from a mimeographed checklist to a fancy catalog with color reproductions. Try to establish a rapport with one printer so that he will develop a knowledge of your needs and style of presentation. On the basis of receiving a job from you every three weeks, he may well reduce his rates, so it is a good idea to work out these details

with him on a long-term basis before you start printing anything.

The one-man exhibitor often pays for all publicity for his show. Besides the cost of the brochure or checklist, there are ads, press releases (which can be photocopied, mimeographed, or multilithed), postage for all mailings, photos for the press (glossy finish, either 5″ x 7″ or 8″ x 10″), and expenses of the opening party. In such cases, the decisions about kind and expense of catalogs and parties are usually left up to the individual artist who is paying, as long as results are not undignified for the gallery's image.

Publicity is not a simple matter of leaving everything up to the individual artist; many artists are babes in the woods about such matters. Your secretary or press secretary presumably has more experience in writing releases and catalog material—or will soon gain it. It is often true that *anyone* can write better about an artist's work and background than he can himself. But he can frequently talk about his work if someone interviews him and asks pertinent questions, then organizes the material so gleaned.

Set up a guest book and ask visitors to write name and address. Thus you build a mailing list of interested people. Also ask each member for names of friends who are potential buyers. Send brochures and press releases to this list, as well as to the local press, and invite them to the opening. The invitation to the opening need not be a separate card; it can be incorporated in brochure or release.

The local press will almost certainly be willing to list editorially (without cost) your shows and hours, if you get copy to them in time for their deadlines. If they have no staff members who cover art, give them release material written so they can use it verbatim, and offer to supply an occasional review or feature article of general interest about the gallery. For photographs to give to the press—whether shots of the gallery, of artists, of works of art—remember that the 65-screen halftone on newsprint is by no means the clearest kind of reproduction. Select subjects that will have good definition and contrast; don't waste negatives on diffuse subjects or work that is all in one tone.

Remember that everyone reads the Letters to the Editor section in publications, so solicit letters on various aspects of the gallery's functions, to build up more awareness and public reaction.

To emphasize the educational facets of your operation, you might invite art teachers to make appointments to bring their students, or Y leaders to bring groups, encouraging them to ask questions of the exhibiting artist and engage in discussions. Perhaps they could also

visit an artist's studio. The press secretary can then write these up for the papers, with quotations from the kids and the artist and factual reports to point up how you are reaching into the community. This is news and publicity.

Posters make good publicity. Perhaps silk-screen them yourselves. Place them in strategic shop windows and on the bulletin boards of libraries, clubs, and other meeting places. It is not difficult to persuade people to display a good-looking poster for an interesting and educational purpose.

It is important to let it be known exactly what are the hours when the gallery will be open, on a regular rather than a sporadic, whimsical basis. It is equally important to be sure that the gallery will really be tended during these hours. I know of one co-op manager who arbitrarily decided to leave an hour early. It was just then that three people arrived from out of town, hence with some effort, to see the show, predisposed to buy. Naturally, they and the exhibiting artist were disappointed and angry, and the gallery's reputation suffered. Better to announce shorter hours, but adhere to them. A few co-ops are open on weekends only.

Certain activities in conjunction with the community may increase publicity and also funds. Perhaps open the season with a benefit show of work by your artists, thus enlisting the co-operation and awareness of those involved with the organization being benefited. Financial arrangements for such shows are often on the basis of one-third to the charity and two-thirds to the artist, with the charity paying costs, which can include something for electricity and overhead. It is a way to reach new purchasers and audiences, as well as a good newspeg for publicity. Sometimes a charitable organization or church wants to hold a "white elephant" sale or auction in the evening or some other time when the gallery is closed anyway. For this they should be willing to pay rent as well as all costs. (I even know of one instance where a gallery was rented for an evening wedding reception providing an unusual and much appreciated environment.)

In such cases it is important to have an artist-member on hand to protect your property and works of art against carelessness and ineptness. Too many people are prone to putting fingers on paint surfaces. Never let anyone bring an umbrella far into the gallery; if umbrellas are stacked in a corner at the entrance, they will not poke holes in canvases.

Some co-ops occasionally put on "guest" shows off-season—late June, early September—introducing work from another city, care-

fully selected by co-op members to maintain their standards. The gallery can charge 33⅓% commission on sales, plus costs of light, heat, and publicity. It may thus collect some funds as well as expand interest in its operation farther afield. If the gallery is normally closed in summer, and a summer group of artists, craftsmen, and/or illustrators wants to use its facilities, again they will pay rent and costs, but again you need to be sure your property is protected. If the work may be beneath your standards, you can insist that mention be made in their notices and ads that you are not sponsoring the show, merely renting space. It need not be that baldly stated, but they can publish that they "have the good fortune to utilize the facilities" of the art gallery "during its vacation period," which will make your role clear.

There may be a lot of work and thought required in operating a co-op gallery. But it is great to be your own "boss," make your own decisions, have the benefit of a "pool" of minds working together, and yourselves benefit from your own proceeds.

11

ARTIST GROUPS AND ORGANIZATIONS

The *Fine Arts Market Place* lists 416 United States art organizations, and no one knows how many informally organized art groups—the ones that frequently spring up and sometimes vanish—may exist.

Where Can You Go to Talk Art?

There are about 1,000 art schools in the country. Periodically such institutions arrange public discussions and display work by faculty and students, outlets that provide some measure of exposure for artists and the opportunity to meet and exchange ideas. We in this country lack one of the most charming and conducive systems of communication, so common in Europe. We do not have the café or coffee house habit, the designated meeting place where artists can drop by on a particular day of the week, knowing they will find other artists of more or less their persuasions and interests with whom they can engage in stimulating conversation and discussion.

Many artists new to New York have asked me, "How can I get to know some other artists here? Where can we talk art? What artists' organizations are there?" I can only deplore the absence of this old European rendezvous arrangement and wonder why we have never developed it. Perhaps it is because we have the barbarous (to Europeans) habit of rushing home to a six o'clock dinner, thus leaving ourselves no free time in the early evening for *l'heure de l'apéritif*. Perhaps it is due to our insistence on being efficient, on inflexibly plot-

ting by calendar each hour of the day. Perhaps Americans are more geared to spending all spare time with spouses. Whatever the reason, our artists are missing out on a rewarding experience, one which has engendered many group activities and many stimulating individual developments abroad. Some years ago I worked with a number of Europe-oriented New York artists to establish an *heure de l'apéritif* rendezvous near the Museum of Modern Art. First we found that though they were theoretically interested, artists were running to catch the next bus home. Then the restaurant, whose back room we had been able to commandeer once a week, folded up! Perhaps some American artists can make a more successful arrangment in a less harried city than New York.

There are more and more artist forums and panel discussions constantly developing around the country—generally in rent-free spaces such as co-ops or other galleries, public library meeting halls or college classrooms or auditoriums. They are usually attended largely by artists who have lots of lively questions to ask and rebuttals to make. After the session is declared at an end, it is often difficult to get the audience to go home and allow the meeting place to be closed. These gatherings frequently stimulate subsequent discussion, conversation and the airing of beefs. Some meetings are geared precisely in this direction: one provocatively announced, "Though the panel participants are of diversified backgrounds and convictions, the focus will be on positive thoughts and approaches, and is in direct opposition to those 'Talks on Art' which propagandize a single point of view, resulting in a further splintering of the art community."

Talking art has also been made more feasible recently by development of artists' unions, such as the Boston Visual Artists' Union, and the various affiliates of the National Art Workers' Community, as well as the rash of organizations of women artists.

Some discussion and exchange of ideas take place at exhibition previews in museums and galleries, although here the tendency is more towards socializing. For really "chewing the rag," artists often assemble in one anothers' studios.

Existing art organizations have many functions; some provide an opportunity to mingle with other artists. Many are not hard to join if your interests are similar. Annual dues are not high—generally from $10–$25 a year. In many cases artists who are already members vote on the new applicants, usually after viewing their work and their records (frequently no formidable ordeal).

Special Artist Galleries

A few galleries in New York have been organized by groups of artists who are already affiliated with regular dealer-galleries. Their purposes are to further the exposure and sale of work by already recognized artists who have more material than their dealer-galleries can handle; the double affiliation is made with the complete agreement of the contract gallery. Usually, the work shown is multiple material such as prints, additional examples from sculpture series, or multiples of mixed-mediums assemblages and three-dimensional molded or pressed forms. Sometimes these special artist-galleries simply handle small-sized paintings, for many dealer-galleries don't want to bother with small works which don't produce enough revenue to pay for their more expensive display quarters.

In other instances, artist organizations have been formed from among dealer-affiliated artists in order to promote additional displays and activities for greater audience, publicity, sales. Some organize summer shows and demonstrations; some promote exhibitions in public or commercial buildings which are increasingly receptive to such activities. These also must be agreed to by the artists' regular dealers, who normally would not object; such extra exposure can be very useful and can add to the prestige of both artist and gallery.

The American Art Directory and Fine Arts Market Place

Every state now has a Council on the Arts. The American Federation of Arts has offices and representatives all around the country. There are organizations specializing in just about everything: for work by veterans, the American Veterans' Society of Artists, Inc.; for watercolors, the American Watercolor Society; for work by women, the National Association of Women Artists, the Pen and Brush Club (New York only), and the Catherine Lorillard Wolfe Art Club (New York only); for sculpture, the National Sculpture Society; for murals, the National Society of Mural Painters; for casein painting, the National Society of Painters in Casein; and for work related to the performing arts, the Library and Museum of the Performing Arts, Lincoln Center, New York.

All these organizations, plus many others, can be found in the *American Art Directory* and the *Fine Arts Market Place*. Because these directories appear only every three years and two years, respectively,

the new organizations constantly developing are, perforce, not included. Moreover, the officer listings for art organizations, museums, and art schools lag far behind personnel changes. It is a pity that supplements are not published at least annually to list additions and changes, as is the practice of the *Art Index*, the standard guide to art periodicals. This valuable reference issues paperback supplements every few months.

There are many art organizations listed in the directories which have no particular specialization: Allied Artists of America; American Society of Contemporary Artists; Audubon Artists (which has nothing to do with pictures of birds, as some artists have believed and have therefore mistakenly avoided the various activities of the group); Knickerbocker Artists; National Arts Club; and Kappa Pi, the international honorary art fraternity with chapters in colleges, universities, and art schools throughout the United States. Most of these organizations periodically exhibit their members' work and also select for showing, either by jury or membership vote, work submitted by non-members. Many organizations which do not have adequate exhibition space themselves arrange to use existing galleries, such as museum community galleries, regional art association display spaces, college or art school galleries, public or commercial buildings with suitable exhibition potentials. The owners or operators of some of these facilities, especially those commercially financed, usually make them available only to acceptable groups to use for exhibition purposes. As an individual, it would be pointless for you to apply directly for such space.

Volunteer Lawyers for the Arts

Individual artists and art groups who need legal advice they cannot afford can apply to a tax-exempt organization founded in 1969—Volunteer Lawyers for the Arts. These lawyers handle hundreds of art-related problems each year, from copyright to tax-deduction potentials to incorporation of non-profit groups.

To apply for such assistance, write to their headquarters: 36 West 44 Street, Suite 1110, New York, New York 10036; state your income, and give a brief history and outline of your problem. If you are eligible, headquarters will refer you to an interested lawyer with whom you can then work with no fee. If your income does not make you eligible for free services, you can nevertheless learn which lawyer is well informed about your problem and hire him if you wish.

Headquarters can supply a handbook *The Visual Artist and the Law* ($5.00—or consult in your library), and a free pamphlet listing similar lawyer groups in various parts of the country, from Oregon and Los Angeles to Boston and the District of Columbia. It can also provide speakers to artist groups on art-related law, and research for individuals or groups on legislative action, proposals and the drafting of relevant bills on federal or state level. As a non-profit, tax-exempt body, it cannot advocate any legislation, but can spell out legal approaches and methods for others who wish to do so.

Informational Organizations

Besides the Art Information Center, Inc., in New York City (see Introduction), there are other international clearing houses of information for and about living professional fine artists and their work. In London, the Art Information Registry, Ltd. (A.I.R.), under government support, supplies free aid to artists on many aspects of their operations. Like the U.S. Art Information Center (which A.I.R. consulted prior to starting its project 10 years after establishment of A.I.C.), it welcomes 35mm. slides, plus résumés, press clippings and catalogs from all professional artists. It maintains visual files of these, open to all, and for a small fee to clients only, provides those interested with addresses of artists or their dealers (unlike the A.I.C. where all is free).

A.I.R. publishes from time to time a useful directory, *Air Mail*, of art organizations and their functions; sources of inexpensive materials for artists and craftsmen; information on science and technology as applied to the visual arts. The booklet is free for the asking; just send a couple of International Postal Order forms to cover mailing costs. Although England is, of course, its major emphasis, there are many entries from other countries and many listings of new publications and other source material of interest to all artists. The address is: A.I.R., Burlington House, Piccadilly, London WIV 9AG, England. Similar organizations are in the process of development.

Business Committee for the Arts

A Business Committee for the Arts was established in 1967 under the aegis of David Rockefeller. Its expressed purpose is "to stimulate, encourage, and advise" in the fields of both the visual and the perform-

ing arts. From ninety corporate leaders as charter members, they raised $825,000. The Committee does not itself administer the funds. Rather, it acts as broker between corporations and various art groups, for purchases and commissions.

It has encouraged and stimulated the formation of corporation collections such as: about 500 works purchased by A.T.&T.—art by young, little known artists selected by employees for their offices; 2,000 works by regional artists purchased by Sears, Roebuck for its "tallest building in the world." It has convinced various firms to finance, for prestige publicity, exhibitions of work by living artists in museums which otherwise could not have afforded them. It has engendered numerous corporation grants to commission artists for work in public places, and has persuaded a lot of banks to offer their walls to regional artists. It sees and communicates with many artists and art organizations in a counseling capacity, giving advice about approaches to implement art projects and proposals that might derive aid from the business community.

The Committee, which operates across the country, has its headquarters at 1270 Avenue of the Americas, New York, New York 10020; it welcomes pertinent inquiries.

Local and Regional Organizations

There are also many local and regional organizations throughout the country. Some are connected with a museum, as, for example, the Birmingham Art Association, which puts on an annual juried show at the Birmingham Museum of Art, holds annual non-juried shows for members, and sponsors each October the Alabama State Fair Art Exhibition. Some art associations and leagues, in areas where no museum exists, help to fill the gap by holding regular exhibitions, competitions with awards, clothesline shows, lectures, classes, and sketch nights. Community art associations frequently utilize local libraries as their show places. Regional groups also exist in most parts of the country. For example, the Pacific Northwest Arts and Crafts Association in Bellevue, Washington, exhibits regional work—all for sale—in juried and open shows and in outdoor fairs in July, with awards and with purchases that are subsequently circulated to schools and municipal centers in the region. Not infrequently, university and art school galleries also serve as centers for regional exhibitions.

Ethnic and National Group Organizations

Certain organizations are established for particular ethnic or national groups. For example, Indian artists periodically show in various museums and galleries in collaboration with the Bureau of Indian Affairs. Black artists exhibit at the Harlem Studio Museum, and many other places in New York and various parts of the U.S. Probably the largest representation of contemporary black art has been assembled by the North Carolina College Museum, in Durham. Work by artists and craftsmen from remote countries of the world can be seen at Carnegie Peace Building and at the Institute of International Education Building, both located at United Nations Plaza in New York City. Jewish artists show at the House of Living Judaism, the Gallery of Israeli Art, and at Hertzl Institute, all in Manhattan. The work of Latin-American and Canadian artists is the specialty of the Center for Inter-American Relations, in New York City. Canadian contemporaries, including Eskimo work, are given fine displays in the spacious gallery of the Canadian Consulate in New York. Other sponsored centers include Goethe House for German art, the Austrian Institute, and the Japan Society.

Artists from Foreign Countries

Artists from a foreign country should visit their consulate in New York or their embassy in Washington, where an attaché concerned with cultural affairs should be able to direct them to special outlets. (I say "should be able" advisedly, for not infrequently attachés refer artists to the Art Information Center, which is all right, too.)

In addition to centers sponsored by foreign governments, there are certain dealer-galleries which specialize in showing contemporary work from particular countries: in New York, exhibitions can be seen of work by artists from Haiti, China, Japan, Armenia, Germany, France, Israel, India, and the Caribbean. There is even a gallery that shows contemporary Persian miniatures!

Artists' Equity and Foundation for the Community of Artists

These two organizations function somewhat like artists' unions, with constant efforts towards improvement of the artist's lot, promotion of outlet and acceptance potentials, dissemination of factual and practical information from health hazards of art materials to hous-

ing and work space, to pertinent tax and legal tips, to sources of grants and fellowships and upcoming open competitive shows. Both are membership organizations—not difficult to join—which offer group rates for health insurance, hold periodic forums and panel discussions, publish newsletters, organize for action on art-related legislation, and often serve as catalysts for airing beefs and controversies.

Artists' Equity Association (AEA) was founded in 1947 and has since undergone various metamorphoses. It is a national organization with 20 chapters throughout the country. Headquarters are at 2813 Albemarle St., N.W., Washington, D.C. 20008. Write there for address of your nearest chapter. New York City's Equity is a separate unit at 1780 Broadway, New York, New York 10019. The much newer Foundation for the Community of Artists was incorporated as a non-profit, tax-deductible organization in 1971; it is more familiarly referred to as National Art Workers' Community (NAWC). Although the double nomenclature may be puzzling, these sister organizational setups enable them to divide responsibilities as they work together—either name will reach them at their headquarters, 32 Union Sq. E., New York, New York 10003. They are loosely affiliated with some branches elsewhere in the U.S.

If the chapter or affiliation of either organization is not very active in your area, its structural framework may be worth solidifying and implementing for greater effectiveness. For their basic premises and goals are probably more truly oriented towards preserving and expanding artists' rights than any other organization in the profession.

Also aiming to improve the lot of the artist and to advance helpful art legislation is the California-based Artists for Economic Action (AFEA), 10930 Le Conte Avenue, Los Angeles, California 90024. In 1974 the AFEA was officially accepted by the Washington Artists' Equity as an affiliate to serve as a model for the unification of local art groups in the U.S. towards passage of beneficial legislation.

Handicapped and Prison Artists

There is increasing interest in stimulating art in prisons, not just as a harmless time-passing device, but as a valuable individual expression which developes personal dignity. Some truly worthwhile products are emerging and being exhibited in museums and galleries. Most needed for wider development are artist-volunteers to aid the prison artists—and to persuade wardens to permit instruction and critiques.

After the 1971 Attica prison riots, the noted black artist Benny Andrews started once-a-week classes at New York City's Tombs to divert destructive energy, leading to riots and suicides, into constructive cultural channels. One noted art critic stated that the results had "more energy and inventiveness than most of what I see every week in the galleries." The classes have spread to other houses of detention and prison hospitals.

In Denver, the tax-exempt Colorado Association for Handicapped Artists of the U.S. was established by a former inmate, Charles G. Cannon, with workshops for training in art skills. It includes prisoners and parolees as handicapped along with paraplegics and others with physical infirmities, because "prisoners are handicapped by incarceration." This practice may become more widespread among other associations for handicapped, such as the various subsidiaries of the Association of Mouth and Foot Painting Artists over the World.

An effective art program was organized in 1973 in the maximum security Auburn prison by then Director James Harithas of Syracuse's Everson Museum, who hired ex-convicts to arrange exhibitions of prisoners' work outside, and of selected museum collection work inside.

The National Endowment for the Arts began in 1974 to formulate plans to lead "in advocating special provisions for the handicapped in cultural facilities and programs." Artists and art groups are, of course, most effective in implementing these aims on the local level. The more active they are, the more likely is their area to receive federal funds for these purposes.

12

EXHIBITING WITHOUT GALLERY OR GROUP AFFILIATION

If you have not yet had any showings—and even if you have had some—you may need to built up your art background and experience before any recognized dealer will take you on. It helps a dealer when he can say to a vacillating customer that your work has been selected by some well-known jury, juror, or institution. If he has to admit you have never shown anywhere, his sales job is infinitely more difficult.

Juried Exhibitions and Competitive Shows

One way to make your art background more impressive is through open competitive shows. A really good dealer in a major art center will submit your work for you; but if you do not have this kind of conscientious or knowledgeable dealer behind you, it is your job to enter the work yourself.

Fairly comprehensive, but not complete, lists of competitive exhibitions are to be found in *Who's Who in American Art*, at the back, and in *Fine Arts Market Place*—reference volumes published by R.R. Bowker Co. of New York and available in any good art library. To inform yourself about the dates of these shows, consult the monthly art magazines, read Artists' Equity and Art Workers' Newsletters, and pay attention to announcements posted on bulletin boards of art schools, of university and college art departments, and of artists' organizations.

American Artist, for example, gives monthly listings under the

heading "Bulietin Board." This is not a selective listing; all shows for which listing fees are paid are published. Here, in fine print, you can find the forthcoming exhibitions to be held in various parts of the country, with details about how to enter and deadlines for application. *American Artist* is a nationally distributed magazine and should be easy to find in libraries. Consult it the first of each month, right after it appears. This procedure is advisable because some listings may require you to apply for entry blanks by the eighth or tenth of the month.

A small entry fee for handling is charged by most organizers of such shows. This practice is under heavy fire by some artist organizations, particularly because rejected artists generally receive no refunds. In some cases, such as where perhaps 2,500 applicants paid $10 apiece, but only 100 were accepted, it means that those rejected paid for the show with no benefit to themselves. Nevertheless, the practice is still fairly widespread. Frequently you are first asked to submit 35mm. color slides for viewing; those which prove of interest may be marked and returned to you with a request that you send the originals for final decision by the jury.

Annuals and Biennials

There are numerous annuals and biennials around the United States which are well worth trying to enter. Some, like those of New York's National Academy and the Audubon Society, are located in art metropolises. Others, such as the Butler Institute of American Art in Youngstown, Ohio, and the Print-Drawing shows at Davidson College, N.C., may seem far from major centers of art purchasers, dealers, and critics. Don't turn up your nose at them because of their geographic location. They have good juries; they publish well-illustrated catalogs which get around to dealers, museums and critics; and they have purchase prizes. Inclusion in such shows will certainly help build up your reputation.

Jurors

Not all competitive shows are worth entering, however. You can learn something about their caliber from the entry blanks, obtainable free on request, which spell out terms and purposes, and usually list names of jurors. If they don't list the jurors, write and ask. If you don't know who the jurors are, look them up in *Who's Who* or *Who's*

Who in American Art. Usually, a jury listing will include each juror's credentials.

A well-known juror can make all the difference between a show worth entering and just a nice local art activity, without any broader value. Some local and regional art groups are sufficiently enterprising and farsighted to obtain topnotch jurors for their annuals, which, though limited to artists from the area, often are not limited to their own members only. The West Virginia Art Association, for example, in recent years persuaded Lloyd Goodrich, long-time director of the Whitney Museum; and Brian O'Doherty, art author, editor, and TV personality, to journey to Charleston as jurors. Even such busy and prominent men like to gain an insight into art activities taking place in various parts of the country. The advantage to the participating artists is obvious, since they can say their work was selected by a well-known juror. Moreover, local press, radio, and television give more complete coverage to the shows because of the visiting expert.

To enhance the importance of their shows in this way, members of local or regional art associations must be willing to put up the funds for a round-trip ticket and a modest honorarium—perhaps $100. ("Honorarium" is the polite term for a sum insufficient to be called a fee for the services rendered.) The visiting juror is usually entertained for two or three days in a private home; he may appear on television and radio; he may give a talk at the local museum or to the association's members while he is in town. Once an association has obtained a noted juror, it paves the way and makes it easier for that organization to persuade other potential jurors in ensuing years.

In the case of smaller shows, art organizations may find it more feasible to obtain the services of a nearby college or university art department head or a local museum curator or director; it may take only two or three hours to jury; it may not call for transportation for a considerable distance; it may be adequate in such instances to pay only $25–$50. Noted local artists are, of course, frequently invited to be jurors.

A lot of artists are eminently capable of objectivity, of appreciation for many veins of work, of recognition for creativity wherever they find it. On the other hand, many artists are limited to their own vision, and this may be the life style that is completely essential to their work. It is no measure of excellence in their own work if they are unable to spread themselves out effectively to other functions. Thus it is understandable that many artists, seeing the name of an

artist-juror whose work they know to be antithetical to their own, simply do not bother to submit. Often they are right; they haven't got a chance. By the same token, it is understandable that museums are diffident about utilizing artists on their boards as determiners of policy concerning contemporary art, its exhibition and acquisition.

But where artists are possesed of the requisite perspective—probably a minority—the would-be competitor is wrong to refuse to submit, regardless of the work style followed by the artist-juror; and the museum is wrong to eschew his advisory services. In each local situation, determination regarding an artist-juror's objectivity can be facilitated by observation of his teaching, jurying, writing style; from his students' work and comments, from prizes he has awarded or selections he has made on prior occasions. One pitfall to watch out for is the artist-teacher-juror who awards everything to his own students—about which there have been numerous complaints. Perhaps jurors would exercise more impartial judgment, instead of false "allegiance," if they were brought in from another region so they would not know the competitors.

Some of the competitive shows conducted by institutions and organizations are aimed at only one style of art. This style may not at all be in your vein, and hence it would be futile for you to attempt to participate. You can usually judge its suitability by the entry form's description of the exhibition aims and the type of juror engaged. On the other hand, don't be misled by a name such as "National Academy" into believing its shows will include only old-fashioned academicians. Actually, the Academy's shows include a wide variety of styles and directions.

Watch out for the kind of competitive show whose aim, if you read between the lines, is purely to enhance the public relations image of the sponsoring organization. Some hotels, for example, have advertised "competitive" shows to be exhibited in the lobby. They often "fudge" about who is to make the selections, using vague cover-up phrases like "juried by noted art experts"—experts who never materialize. They offer some prizes—and charge the artists enough per entry to pay for them. Such exploitative competitions are likely to accept all submitted works, without selection, as long as payment is received. Its promulgators hope for hotel publicity by getting on the art band wagon, aiming to maneuver the show so that you, the artist, will pay for it without benefit to yourself. Shows like these are not covered by prominent critics or museum curators. Instead of adding to your art background, they just drain your pocketbook.

A notorious example of fraudulent art fairs was a big, widely advertised and publicized fly-by-night operation perpetrated several years ago as the "Da Vinci" art festival. Space was rented at New York's Coliseum; large prize monies were promised as well as exhibition space; thousands of works of art and thousands of dollars in entry fees poured in. The operators went broke before the festival opened. Had it not been for quick and effective action by State Attorney General Lefkowitz, the artists' works would have been sold to pay operators' creditors. But there was no way to reimburse artists for their considerable losses in packing, shipping, insurance costs.

As a result of this major fiasco, Lefkowitz suggested legislation to control such false allegations and agreements; a bill was passed by the New York State legislature, but it was vetoed by then Governor Nelson Rockefeller.

Shipping and Packing

The three main services used to ship work to exhibitions are Parcel Post, Railway Express Agency (REA), and United Parcel Service (UPS). All these conveyors are full of vagaries and inconsistencies regarding their rules and rates for art shipments; their insurance, size, and packing requirements; their geographical discriminations. REA air rates can turn out to be considerably cheaper than surface shipment; 1st class post offices often—but not always—will ship only half the weight acceptable to smaller post offices. It may be useful to check your post office regarding use of "Special Handling" and/or of "Express Mail." "Each instance may be different," they all blandly tell you, instead of organizing themselves in some orderly and consistent fashion.

Until and unless these services establish and publish uniform rules and rates, it behooves the artist to do comparative shopping in "each instance"—or else just close his eyes and ship any nearby way. Museums and art organizations seem to have a habit of returning work C.O.D. via the most expensive way. It would be helpful to artists if they too made comparative inquiries first.

Department Store Galleries

Department stores are becoming increasingly involved in contemporary art, many having established separate areas for galleries within their precincts. Though by no means a new departure, this activity is

definitely becoming more widespread. A few department store galleries, such as Gump's in San Francisco and J.L. Hudson in Detroit, are generally accepted in the same category as other professional galleries in town.

So far, however, the majority of these galleries have not "made the grade" professionally. A kind of snob rejection still prevails. But time, as well as careful selection and operation, could break down opposition. There is, indeed, a substantial argument in favor of these outlets, which offer something of a captive audience and which do not intimidate the young or new purchaser who is apt to think—quite incorrectly—that if he even walks into an art gallery he won't escape without shelling out a sizable sum. He (or more often, she, in this case) feels more at ease in a department store, where he knows his way around and understands how, if need be, to apply the requisite sales resistance.

A number of department stores have started galleries which emphasize "safe" work by big names—often in the less expensive graphic mediums. In some instances, the examples are dubious; they may be lithographic reproductions of original lithographs, misleadingly advertised as lithographs by the artist. The eminent Print Council of America tried valiantly to thwart this practice. Too few purchasers are aware of the Council's definition of a truly "original" print, or how to determine whether they are buying from a genuine "limited edition," and too many are taken in by misleading labels and ads. This dubious practice, only occasionally found in department stores, is, unfortunately, not hard to find elsewhere.

One hopes that department store galleries will demonstrate more courage about taking work by newer, less-known artists. Their approach and quality, of course, depend upon the caliber of the gallery director and on the degree of independent judgment he is allowed by his employers. As attitudes become more enlightened, department stores may become promising outlets, providing contemporary artists with a growing market. Don't be surprised if they charge 50% commission on sales, for they tend to treat art like their merchandise on which they place a 100% mark-up.

Bookstores

Some bookstores also set aside areas for art galleries. Sometimes they specialize only in original book illustrations. In other instances, they express a genuine interest in contemporary, non-illustration works of

art. Within its domain on Fifth Avenue, the old established Brentano's in New York operates the Galerie Moderne, where group and one-man shows—often by younger artists—are a regular feature. In other cities where there are fewer art galleries, bookstores may generate more art activity—not necessarily because they are nobly filling a gap, but perhaps because they are "latching on" to another sales potential. If a good bookstore in your city has not heretofore shown art, you might persuade the owner that it is the coming thing to do so.

Be prepared for the "safe" attitude in some of the big bookstores which do display art—but only by well knowns. An artist who came to see me the other day said she had gone to Rizzoli's, a *de luxe* Italian bookstore in New York which shows and advertises big-name art. She was told, she said: "You will only become the two-thousand-and-first on our list of applicants." It is not hard to tell, just by looking around, which firms show only established artists; it may be a bit harder to persuade them to alter their policy.

Banks

With all their dull architecture built from the wealth derived from our pockets, banks have taken over huge street-level areas with great display fronts of plate glass and thermopane. Yet they have nothing to display, which makes walking along the avenues a pretty boring affair. A few banks, having become vaguely aware of their lack of eye appeal, have been willing to use their great picture windows for art—even, occasionally, for a pretty female artist actually painting on the spot. A new and fancy branch of a savings bank recently opened in my neighborhood with more street-front display windows than any ten New York galleries put together. There sat a young lady painting, gawked at by mobs, all kinds of people on the sidewalk, from the soup kitchen line of the nearby charity house to the brokers of the nearby stock exchange house. After the opening weeks, no more art appeared was to be seen.

Obviously it is going to take enterprise and boosting on the part of artists if they wish to jolt these firms out of their familiar and comfortable ruts, but it has been and can be done. Individual artists and groups, such as New York's Artists' Equity, have more often engendered such activities in banks than have the banks' own personnel. Even though this kind of display has not yet commanded much profession recognition, the enormous viewing advantages of these showplaces make them potentially prime art display spots. This is what

happened at Lever House on Park Avenue, whose directors long ago realized they could not make appealing shows out of acres of their soap, and so gave over their exhibition space to art. Exhibitions at Lever House are recognized professionally and do get reviewed. Besides, they can be seen day and night, for they are lighted after the building closes and are fully visible from the street through the glass walls. The Lever House managers simplify their role as arbiters by accepting work by established groups only; these groups encompass many artists and styles. There is no reason why bank outlets, if intelligently and imaginatively administered, cannot achieve the same status.

Libraries

All over the country libraries are devoting more and more space to contemporary art shows. Again, much has been achieved by artists themselves. A happy example is the public library in a little New England town which I visit on weekends. In recent years, the library's volunteer board of directors was persuaded by one of the directors, herself an artist, to permit her to organize regular shows of contemporary art on the library walls. She has kept the library buzzing ever since with art and artists—some local, some "imported"—with openings and, in good weather, outdoor sculpture on the lawn. Good local publicity and sales have resulted, as well as a new awareness of art on the part of many local residents, some of whom have been inspired to make their first art purchases. Libraries have tax-supported space and a regular audience; generally they simply need some help and know-how to start such an operation. The chances are that most libraries will welcome a practical suggestion and plan of operation.

In big cities, certain branch libraries specialize in art because of their locations; some of them have especially designated art galleries. In New York, for example, there are galleries in the Donnell Branch of the New York Public Library because it is located across the street from the Museum of Modern Art; and in the Schomburg Branch, which for many years was the only major showing place in Harlem for black artists. Some city libraries put on only group shows; others arrange one-man exhibitions. Such libraries usually have regular opening previews and often sponsor related talks, discussions, lectures, demonstrations, and films. Works are for sale. Not much major publicity attends these shows in large cities, but they do

successfully reach neighborhood audiences. Participating in library exhibitions gives you experience—and exposure of your work under any reputable auspices is not to be sneezed at.

Churches

One tends to think that liberal religious sects—such as Universalist, Unitarian, or Community churches—are those most open to encouraging contemporary art. Indeed, they often are favorably inclined and hospitable to artists; but they don't have a corner on the market. Some of the reputedly "staid" denominations—like the Presbyterians and Episcopalians—have become interested and are mounting shows in their parish houses, auditoriums, or Sunday school rooms. Some of them seek out contemporary work which has a Biblical context. It is occasionally apparent that if the title alone has some religious reference, the church will happily include it, regardless of any evident visual relationship to a religious theme. Perhaps a reverent title suffices to justify the show to a Board. Others are unconcerned about content and title.

Church and synagogue interest in modern art has been manifest for many years both here and abroad. They have often led the way, especially in architecture, where church design (perhaps most notably the Catholic and Jewish) has really pioneered and has embraced the arts of stained glass, tapestry, mural painting, sculpture, and altar accessories to embellish their new buildings. Not only have they exhibited, they have purchased and commissioned works of art as well.

In small communities, churches are often interested in showing contemporary art, particularly if they don't have to worry about paying guards and insurance out of small budgets. Actually, the church is probably safer from theft and fire than an artist's home or studio. Again, in my small New England weekend town, I have been asked on several occasions by a local minister about the possibility of showing modern art in his new parish house. He must really be interested, for we never meet in church, but only over a beer in the one local lunch room. Although he has shown many good art reproductions, he has been scared about assuming the responsibility of displaying originals. I suspect that he and many other clergymen in similar positions would happily display work by local artists if these artists offered their encouragement and help in selecting, installing, and protecting the shows.

Furniture Stores

Some forward-looking furniture stores which are open to the public (for "trade" outlets, see page 70) make a practice of inviting artists to display work in their showrooms when they feel the art is compatible with their merchandise. Their managers are usually entirely willing to sell the art—often without commission—charging the artist only for such expenses as framing and customer delivery. The works of art and the furniture displays complement one another, and the enlightened manager likes to see his wares thus enhanced. Often these stores change the art about once a month, perhaps showing one painter and one sculptor each month. If you see a handsome display of furniture, with or without concomitant art, it can do no harm to show the store manager reproductions or examples of your work for potential inclusion. Also, the manager with no art in his store may just not know where to get it.

Charity Shows and Auctions

New York dealers are apt to frown on frequent requests for donations from their artists to large, fancy charitable sales and auctions (see page 62)—and with reason. However, New York artists with no gallery affiliation tell me that contributions to small, out-of-town churches and synagogues and charitable clubs can be worthwhile. The expectations of these organizations are more modest—they usually ask only for 20% to 25% for charitable purposes. When the charitable sale takes the form of an auction, the artist can insist on placing a minimum bid on his work. In general, this is the only kind of auction that makes sense for the living artist to participate in. The regular auction houses usually sell work by living artists only when it is included in a whole collection or estate, and such auctions are not the concern of the artist.

Suburban Galleries

Some city artists have also found it profitable to go out of town to suburban galleries. They load up a station wagon with work and cruise around showing it. They find that numerous galleries of this sort are pleased to have work brought to them on consignment; these galleries charge no expenses and generally expect a commission on sales of only 33⅓%. It is well to keep in mind that people who buy in

the outlying areas are not likely to spend as much as if they were to go into the city for a major purchase. Smaller works and graphics are more suitable than a major opus.

Studio "Open House"

Artists who have no gallery commitments sometimes hold "open house" at their studios, usually on weekends or an occasional evening. In New York, several artists in a neighborhood occasionally get together and advertise that they will all have open house on the same day so that the visitor can easily go from one to another on a single trip. Some artists have sold by this device, others have not. Occasionally, they have received good publicity, as in the case of the "10 Downtown," centered around the New York area where so many artists work. This unusual organization rotates the studio viewings to a different set of 10 artists each year; each artist selects another for the following year's showings. Thus the "mantle" is handed on, and a fresh set of shows appears for three weekends each spring, advertised jointly with a map to guide visitors to the 10 neighboring locations.

In San Francisco, local artists have coordinated open-studio exhibitions in an area zoned for light industry, where a number have found it expedient to rent fairly spacious studios.

The pupils of artists who are teachers are also potential purchasers. They usually want to visit their teacher's studio, and this often results in a sale.

Barter

Many artists exchange works with one another. I know one artist who had visitors at his studio open house only to find that one of them preferred his friend's work obtained on "swap." Instead of being insulted, he sold the friend's work. The friend, who had the same privilege of selling the work he had obtained in the swap, was pleased to learn he had another collector. Some artists who are better salesmen than their friends have hung in their studios some work by friends along with their own, and have sold for them on a commission basis.

Thus the artist, without gallery affiliation but with ingenuity, has been able to devise numerous ways of exhibiting and selling. And the old barter system of exchanging art for needed services or mate-

rials has long worked for many artists. Doctors and dentists for years have been noted for their willingness to be paid in art—and not just because they have offices and waiting-rooms to decorate (a form of exposure for the artist), for so do lawyers, who are not so noted for taking barter payment. Doctors and dentists are sufficiently interested in painting and sculpture to have established numerous art organizations around the country which periodically show their own hobby work. And there is an occasional expert in both fields—such as Herbert Ferber, one of our most noted sculptors who, under another name, is a highly professional dentist.

The medical-artistic affinity may perhaps be explained only by psychiatrists. But the barter trend is spreading into many other fields. An artist recently told me that he had had a carpet laid in his apartment. The man who installed it said, "You painted these pictures? Well, I'd rather have a picture than the money." The artist was indeed surprised, but he claims that a lot of artists practically live on barter. Electricians, plumbers, wall painters, and accountants have been known to take art in lieu of pay.

Open-Air Shows

There are, of course, many summer art centers and competitive juried shows. These are more likely to take place outside major cities, in summer art colonies, resort areas, or just wherever artists organize them to keep life-blood flowing in the dog-days, which are often difficult for art survival and continuation. Summer exhibitions are unlikely to be one-man shows; are generally geared to appeal to the tastes of collectors in various directions and styles, and are usually not in the high-priced brackets.

All over the country there are "clothesline," village green, or sidewalk exhibitions during good weather. Many of these shows may not amount to anything professionally—they are basically for amateurs—but they may produce sales. Some, on the other hand, are competently juried by professionals and also display invited work by recognized artists. A well-organized outdoor show with jurors, such as Boston's annual, puts to shame New York's Washington Square show. The latter is available to anyone who rents sidewalk and fence space—an odd practice since the sidewalks and fences do not belong to those who collect the rent for them. There has been talk for years of making the Washington Square show more like the Boston—perhaps this discussion will one day bear fruit.

It probably won't hurt your reputation to show even in the unjuried outdoor exhibitions. I have known several professional artists newly arrived in New York who unwittingly took their work to Washington Square, and subsequently went on to reputable dealers who did not hold this against them, realizing their naiveté. But there is quite a bit of work and time involved in such shows: you usually have to be personally responsible for everything, including babysitting your part of the show. The question you must answer for yourself is, is it worth it? Is it going to add up to something on your art background record? On the other hand, it may be worthwhile for local recognition in your area, and for revenue from sales.

Another consideration, on the other side of the picture, is the problem of pricing, with resultant effect on sales potential. A watercolor artist recently visited the Art Information Center thinking to seek regular gallery outlets instead of traveling around to open-air shows. For some years he and his wife, spelling each other in baby-sitting his shows, had made the rounds of the open-air exhibitions, from New England to Florida depending on weather. In this fashion he had regularly sold most of his output.

When he realized that, should he have gallery representation, 50% would have to go to the dealers, he began to wonder. Would his market bear the increased prices (doubled, in order to give the dealers their 50% commission and to give him his usual price)? Would he sell many fewer and wind up with much less income?

Moreover, I reminded him that if he had New York gallery affiliations, for instance, the dealers would object to his selling in Washington Square at half-price. For even when galleries take work on trial consignment and ask no exclusivity, they understandably do demand that other sales outlets be in line with their price structure, especially in nearby locations. Thus his carefully built-up open-air outlets might be severely curtailed if not cut off entirely.

The watercolorist went away, determined at least to look into my suggested gallery possibilities, but at the same time thinking out loud about weighing these against potential losses, as well as against costs of travel, portable racks, motels. I wonder what he will decide. Perhaps wanderlust will win out over other considerations.

Museums and Lending Libraries

If the museums in your area show contemporary art—and many do—their curator of painting and sculpture, or their curator of graphics

will usually see work, or slides of work by living artists. It can do no harm to call the curator's office and inquire as to the procedure, for systems vary considerably in different museums. The Whitney Museum in New York, for example, suggests that you leave or send slides along with a return, stamped envelope. Slides should be of recent work, in your current style, each labeled with dimensions of original, medium, and your name. From these, the Whitney picks some works for its biennials and, sometimes, for special theme or medium shows. Don't expect the museums to make comments, judgments, or criticisms of your work. They usually make their own notes, but say nothing. You have nothing to lose except postage, and you are at least entered "in their records."

Even those regional museums which are notoriously old fashioned about exhibiting modern work are more open-minded about showing their own local artists. They manifest an almost forced attitude of community responsibility, and they are more apt to receive newspaper publicity if their "local boy makes good." Museums just love publicity; it pays off well with their trustees and other donors. Consequently, if you are a "local" artist, you might as well cash in on this home-town situation.

Some museums have art lending libraries—often as a special privilege and as a come-on for membership in the museum. People can rent works of art which are for sale, usually applying the rental price onto the sales price if they decide to buy the piece after living with it. The rental period is usually limited to about two months.

At New York's Museum of Modern Art, the rental fee is 10% of the purchase price. Work available includes paintings, drawings, prints, and photographs, with very little sculpture because of its high cost and difficulty in handling. Most selections come from dealer-galleries, although there is some independent work. The program is conducted by the Museum's Junior Council of donors which hires a professional adviser, who must be approved by the curatorial staff, to make the selections. All museums have to pander to their donors in one way or another; the operation by the Council of its own special project makes for greater involvement and identification with the museum's functions, and hopefully more purchases of modern art, more donations of both art and money to the museum.

Unless the two-month rental results in a sale, the artist receives nothing, the proceeds from rentals being absorbed by insurance and administrative costs. There are pressures afoot from some artist organizations to pay artists 50% of rental fees and not to allow the fees

to be a form of installment purchase. Another aspect resented by some artists is the possibility that if their work is not bought by the renter, a pejorative stamp may be put on it—a kind of "used and rejected" label. There may also be a problem if a new work goes in and out of rental over a period of, say, a year; after this the work is likely to be eschewed by the artists's dealer as too old—in the cult of demand for newest, most recent.

Art rentals are operated not only by museums but also by some dealer-galleries here and there. Some artists have found them useful for exposure and sales; it may be worth your while to look into this potential outlet.

13

"ORIGINAL" PRINTS AND "LIMITED" EDITIONS

In this era of popularity and upsurge in the making and buying of prints in the U.S., it may come as a surprise to realize how recent a development this is. The idea of the original print as a work of art emerged largely after photography and photomechanical reproduction effectively replaced engraved reproductions from paintings.

Print Council of America

The eminent print collector, Lessing J. Rosenwald, wrote in 1961: "Until recently, few of our fellow Americans had any knowledge of the graphic arts, much less any appreciation of fine prints. In 1956 a group of print experts initiated a movement to stimulate public interest in original prints. From their meeting resulted the Print Council of America, Inc. Almost immediately its activities proved to be of significant benefit to the public, as well as to artists, museums, graphic workshops, print clubs and private collectors."

The Council, then composed of 41 top experts across the country, achieved considerable success in its aims and purposes. The Council's early pamphlet, "What Is an Original Print?" is now unfortunately out of print. Mr. Rosenwald, as President, wrote in his introduction to the pamphlet: "One of the stated purposes of the Council—which is dedicated to the diffusion of knowledge about prints—is to 'promulgate standards, codes, formulas, and recommended procedures' in the graphic arts. . . . In recent years there has been a phenomenal growth of interest in making and collecting

prints. The print has gained increasing recognition as a major art form; it has become more important in an economic sense as well as esthetically. There is, therefore, an increased necessity for standards of originality and for knowledge of artistic and trade practices."

Definition

The Print Council promulgated a definition of an original print, similar to those concurrently accepted by the U.S. Customs, by the French *Chambre Syndicat de l'Estampe*, and by the International Association of Plastic Arts of UNESCO; thus giving rise to formulation, acceptance, and adherence to certain basic requirements theretofore not spelled out or publicized: "An original print is a work of art, the general requirements of which are:

1. The artist alone has created the master image in or upon the plate, stone, woodblock, or other material for the purpose of creating the print.

2. The print is made from the said material by the artist or pursuant to his directions.

3. The finished print is approved by the artist."

Because of sharp practices that have developed in the field, not only collectors but artists and dealers as well may often be in need of definitions to avoid slipping inadvertently into fraudulent misrepresentation. The foregoing definition does not eliminate teamwork between artist and master printer, as long as the print is made by the artist "or pursuant to his directions," and "approved" by the artist. Collaboration between artists and skilled printers, practiced by many old masters, has experienced a revival; partly because of the operation, begun in 1959, of the Tamarind Lithography Workshop sponsored by the Ford Foundation. There is no reason why a fine artist should learn intricate printing techniques which are the specialization of the trained master printer, as long as the artist-creator is the final arbiter.

Reproductions

It has been too easy for everyone to be duped by excellent reproductions, produced either photomechanically in unlimited editions (as in some of the so-called "original" Toulouse-Lautrec posters); or

made by craftsmen as copy-reproductions, often in limited editions and even signed and numbered by the artists. These are not originals; they are simply autographed reproductions. This practice has been particularly widespread in France. Reproductions are dutiable while original prints are duty free, as is spelled out in detail in the U.S. Tariff Act, Par. 1807 and Par. 10.48.

Recommendations to the Dealer

The Print Council has suggested these standards for a dealer:

1. He should not describe any print as an original unless it fulfills the three conditions of the above definition.

2. He should issue a written invoice for prints sold and distinguish reproductions from originals also in his catalogs and advertisements.

3. He should include all pertinent data available about collaboration on plate, signature and numbering, processes used and by whom, condition of print (such as cut margin or restoration), states, size of edition and number of impression, signature, date, cancellation of plate.

4. He should obtain from artists and publishers the best possible evidence that work is original, how made, catalog information and number.

5. He should help the public to understand the difference between a reproduction and a true original.

Recommendations to the Artist

The Print Council has recommended to the artist:

1. Try to adopt uniform practices in numbering and signing prints—in some cases editions are deceptively numbered and described.

2. If the artist does the printing himself, he might write after his signature, "imp." (*impressit*—he printed it). If a master printer executed the work, a proper indication would be "X [artist] del., Y [printer] imp." This does not necessarily apply to transfer lithography, in which the artist is considered to have made the image if he supplied the greasy crayon drawing for direct transfer; but not if he gave the printer a drawing as a model to be copied in crayon by someone else. In the latter instance, the result is considered a reproduction.

3. He should not sign any reproduction unless this fact is clearly stated, for this only tends to foster the illegitimate market.

4. Trial proofs from unfinished states are not part of an edition. But artist's proofs are definitely to be included in the total number of the edition; the number of both to be determined by the artist. The maximum size of the edition should appear on each impression.

5. He should use his best efforts—even with color prints using more than one plate—to number individual prints consecutively.

6. If he reuses a plate from which a full edition has been pulled, he should use different colors and mark the new edition "2nd Ed." If he reworks the plate substantially, such prints should be marked "2nd state."

7. He should destroy the image once an edition is completed, or cancel it by altering the design distinctly, such as cutting a curved corner on a rectangular plate.

Prints not in Editions

There is a place for the artist who keeps on printing from a plate as long as it is in good enough condition, provided he does not claim a limited edition. The Print Council says: "There is no reason, from an aesthetic standpoint, why the number of prints should be limited, except that the quality may deteriorate if too many are printed. However, if it is claimed that an edition is limited, it must be limited in fact."

I know a number of artists who either cannot decide how many they should print—it is hard to guess ahead of time how many will sell—or simply don't want to bother keeping track of numbers as long as the plate continues in a condition which still makes them proud to call the works their own. These artists, while not bothering about numbers, do pay attention to the quality of impressions and effects of wear and tear. Even original copper plates by Rembrandt, of which the North Carolina State Museum in Raleigh owns 96, have little value—except as a curiosity—beyond that of the copper, so worn are the images.

If you aim at the investor market, it is wise to adhere to the widely accepted stipulations. Yet there will always be those who make and buy prints for the sheer pleasure of the art itself.

14

TAXES AND
SELF-EMPLOYED
ARTISTS

Commenting on the confusion of tax measures and decisions in the artist's domain, the Associated Councils of the Arts wrote, "Tax procedures with regard to such matters are in almost complete disarray." Despite this gloomy assessment of the situation, there are some measures the artist can take under consideration, some facts he can assimilate which may make life easier and perhaps less costly as far as taxes are concerned.

Keep Records

First of all, to qualify as a self-employed artist, you must show continuous effort to make a profit from art as a profession, to prove you are not just dabbling in art as a pastime like Sunday painters. This requires being business-like: keeping careful records and accounts of all costs related to your profession as a self-employed artist. If you are also employed elsewhere, such as in teaching, these income and outgo records need to be maintained separately. You will need all such reports whether you work out your own tax forms or hire a Certified Public Accountant to do them for you.

There are various pamphlets and tip-sheets to consult, which go into greater and often updated detail, published by Volunteer Lawyers for the Arts, Artists' Equity, National Art Workers' Community, American Artist Business Letter, Art in America's Art Letter, and others. But some basic accounts to keep are those related to sales receipts, payments for art activities such as lecturing and jurying,

materials and equipment, studio costs, travel or shipping costs to deliver and collect your work, travel and housing for art conventions and professional meetings or for research in your field, travel to exhibitions for educational purposes or to expand your professional knowledge. The IRS will usually accept one-half the cost of such travel expense without question; beyond this percentage they may figure that you only spent part of the trip on self-improvement, that you must have enjoyed yourself part of the time (probably true). Sometimes the whole cost can be proved to be legitimate deduction.

Keep in mind that if you have a particularly good year, in which your income exceeds 30% of the total of the prior four years, then Income Averaging over those five years may well benefit you; get the IRS Form 1040 Schedule G.

Keogh Plan

For whatever part of your income derives from self-employment, such as sales of your art, you can take advantage of the Keogh Retirement Plan (Keogh was the Congressman who sponsored the legislation in 1962). The Plan allows you to put up to 15% of your total self-employed earnings into a savings bank (practically any savings bank) for a period of either three or five years at your determination. You will receive bank interest, and you can deduct from your taxes each year, except the last two, the entire amount deposited in the previous year. This Plan provides a substitute for the retirement benefits enjoyed by those who work for employers, and at the same time a legitimate tax deduction.

Inheritance and Gift Taxes

Every U.S. citizen must pay inheritance taxes if the total assets inherited are $60,000 or more after deduction of estate debts and expenses. A legal method for reducing this burden on your heirs is to make gifts during your lifetime.

You can give property, such as works of art, in values up to $3,000 per year per person—with no limit on how many persons—without payment of any tax either by you or them. Remember, at death, the works in an artist's studio are taxed at full market value.

You also have an additional tax-exemption gift potential of $30,000 for life. Thus, should you give something valued at $4,000 one year to one person ($1,000 more than the $3,000 normally

allowed), you will have dipped into your lifetime cushion so that $29,000 will then remain in this extra category of tax-deductible gifts. Of course, it is necessary to have some kind of authenticated appraisal. There is one government rule about these tax-free gifts: you are not allowed to die within three years of the time of the gift, for then the government will assume you made the gift in anticipation of death (even accidental death), and it will then require full payment of inheritance taxes.

It is impossible to spell out any uniform stipulations about estate taxes in the various states, for they vary, and in some cases do not have as liberal allowances as those of the federal government. But many states do have such taxes which must be taken into consideration, in addition to the federal.

Tax Reductions on Purchases of Contemporary Art

An interesting idea, incorporated into a bill introduced in Congress in 1974, was instigated by the Artists for Economic Action towards aiding the artist who needs more sales to be able to spend more time on his creative work, less on earning an outside living. The bill aims to make it easier for lower-middle income collectors to buy art and to build up a clientele for art by living Americans. Such expenditures would be deductible from taxes up to a limit of 10% of income, not to exceed $10,000 per year, or a maximum deduction of $1,000 in a year. This precludes the possibility of misuse by the wealthy collector for any tax loophole potentials. The IRS would recover most of the purchaser's exemptions from the seller's additional income; the living artist might well benefit from this encouragement to purchasers should the bill pass.

15

SEXISM IN ART

It would have been interesting to know how many women classified themselves as artists in the 1970 Census as compared with men, so I asked the Bureau of Census, which said it would send me the figures. But after three years of compilation and voluminous breakdown reports, the Bureau wrote: sorry, we made a mistake in promising—no figures were compiled on artists or art teachers—only on every other imaginable occupation. At least they do not discriminate: they omitted male as well as female artists!

Press Bias

A series of studies was made in the early 1970s by the Los Angeles Tamarind Lithography Workshop analyzing a full year of art review ratios for male and female artists, in a number of major national magazines and newspapers. The title: was "Sex Differentials in Art Exhibition Reviews: A Statistical Study." Its revelations were pretty devastating, e.g., *Time* reported on 52 men artists, 6 women; *Newsweek* on 109 men, 4 women; *Art in America* reviewed 12 men for every woman and gave 17 out of 240 reproductions to women's work; *Art News* gave eight times as much coverage to men. *The New York Times*, while less discriminatory about women artists (largely because of Grace Glueck, a most lively and forward-thinking reviewer), covered fewer living artists of either sex than either the *Los Angeles Times* or the *San Francisco Chronicle*, giving more space to historical shows and dead artists.

Although there seem to be no available statistics on how many women exhibit as compared with men, there may be some implications and assumptions to be derived from the fact that more women than men obtain degrees in fine and applied arts. In 1968, such degrees went to 7,246 men and to 9,473 women; yet a recent faculty count in six major art schools and university art departments in the New York area showed a ratio of eight men to one woman.

Women's Organizations

There are numerous activist organizations protesting these situations, often quite effectively. Percentages of women in museum shows are steadily mounting, though not, so far, reaching near a 50% level. The well-known, long-time art critic, Emily Genauer, in her syndicated column, enunciated a plea: "Why shouldn't women get their fair share of exhibition space? . . . How do we know how good women artists are when statistics prove only a small proportion of them have gotten their work shown?"

The women artists' groups have been flourishing in far-flung areas and influencing the country particularly since the 1960s. They introduced the term "sexism" as a repression concept parallel to "racism," and have consistently worked for equality. When confronted by one of their posters, as late in the "movement" as 1970, the then New York Governor Nelson Rockefeller asked the women, "What's sexism?" This son of one of the three ladies who founded New York's Museum of Modern Art very soon became fully aware, as did the rest of the U.S.

The United Nations declared 1975 as International Women's Year (a logical sequel to its 1974 World Population Year) with big festivals of international women's art. Women's art centers, registries, exhibition areas, propaganda, and promotion activities have proliferated over recent years, and a number have even received government grants. Prognostications for improvement in the biased situation, in the inclusion of "sex" as part of the basic concept of "regardless of race, creed or color," seem warranted.

In general, it is probably still true that the woman's work has to be better than the man's to make the grade. But women in every field are inured to this as a fact of their lives.

16

SAMPLE FORMS

Contract Form

Many galleries draw up some kind of a contract which artist and dealer sign before holding a one-man show. These contracts vary considerably; sometimes they are not a form at all, but merely an exchange of letters; occasionally, agreements are purely verbal. The following, filled out in duplicate, is a typical formal contract.

1. The (name) ...Gallery, (address) .., referred to hereafter as the "Gallery," agrees to act as sales representative for (artist's name) .., referred to hereafter as the "Artist," for a period of ...year(s) from date.

2. The Gallery shall receive.....................%, [33⅓% some many places, 40% on painting and sculpture, 50% on graphics in large art centers] of all sales made on its premises.

3. The Gallery shall receive% of all portrait, sculpture, or mural commissions that it gets for the Artist, and% of any others awarded during the contract period [because the gallery's promotion has built the artist's reputation; and because the artist may not sell directly in competition with his dealer].

4. The Gallery shall not receive any commissions on royalties, sale of reproduction rights, or commercial assignments unless arranged by

the Gallery, in which case the commission will be%.
It shall be understood that all sales are made exclusive of reproduction rights, and written acknowledgment of that fact shall be obtained from purchaser by the Gallery. Reproduction rights may be specifically purchased with the Artist's written consent in each case.

5. The Gallery shall not receive commissions on prizes or awards granted to the Artist by art institutions, foundations, or a government agency.

6. During the period of the contract, the Artist shall not contract for any other representation, except in the following fields if they do not conflict with the Gallery's outlets:

 a. representation outside the city in which the Gallery is located

 b. foreign countries

 c. multiples

The Gallery may arrange for representation of the Artist by another agency, but will pay such agency by splitting its own commission.

7. The Gallery will act as continuous sales representative for the Artist, keeping always available a few examples of work. The Gallery will exhibit the work of the Artist in a one-man show of
weeks' duration [usually just under three weeks]. At least one work will be exhibited in all gallery group shows.

8. The costs of a one-man show will be borne by the Gallery, except for publicity costs, the actual bills for which are to be paid by the Artist. Publicity costs will be deemed to include only the costs of: printing and mailing of brochure; advertisements; photographs for the press; preview costs (if any). The Artist agrees to pay publicity costs in advance.

9. The Gallery will pay costs of packing and shipping work sent to clients and exhibitions. It will insure work against loss or damage while the work is on its premises only; insurance will be at%
[average: 30%-60%] of price the Artist would receive if the work were sold.

10. A written agreement will be signed by Artist and Gallery on prices for all work left on consignment. Only with the written consent of the Artist may the Gallery accept a lower price. Should the Gallery obtain a higher price, it is guaranteed that the Artist will receive his same percentage of the total proceeds.

11. Payment to the Artist for any sales made by the Gallery shall be made within fifteen days from the date payment is received. If payment is to be made in installments, the Artist's prior consent shall be required, and payment to the Artist shall be made within fifteen days after final payment is received.

12. All works are received by the Gallery on consignment and in trust. The net proceeds of all sums received by the Gallery on account of works sold shall, after deduction of commission and expenses agreed upon, belong to the Artist.

13. The Gallery will give the Artist a written receipt for all work received; the Artist will sign a receipt for all work returned.

14. The Gallery shall keep records of transactions regarding each Artist's work, records which the Artist may inspect at any time during business hours.

15. This agreement may be canceled by either party up to three months prior to the opening of a one-man show by giving five days' written notice. No cancellation may become effective, however, if the printing or advertising for a show has already been placed.

Date: ..

Gallery Official ..

Artist ..

Bill of Sale Form

(to be filled out in duplicate)

Place ..

Date ...

Name ..

Address ..

Sold to: ..

Description of work: Price:

Terms of payment:
Reproduction rights reserved

Purchaser (signed) ...

Authorized Dealer or Artist ...

Receipt Form

(to be filled out in duplicate)

Received from:
Name of Artist ..
Address ..
Phone ...

Title	Medium	Size	Sales Price	% Commission
1.				
2.				
3.				

To be held until (date)

While the works listed above are on the Gallery's premises, they will be insured against loss or damage for the benefit of the Artist at % of the sales price less commission. None may be removed during the exhibition except as agreed in writing. Reproduction rights reserved by the Artist.

Date ...
Authorized Dealer...

INDEX

Edited by Claire Hardiman
Designed by James Craig
Composed in eleven point Baskerville by Publishers Graphics, Inc.